MONT

NATIVE

PLANTS

and

EARLY

PEOPLES

MONTANA
NATIVE
PLANTS
and
EARLY
PEOPLES

researched and written by JEFF HART

illustrated by JACQUELINE MOORE

Montana Historical Society Press
Helena

Cover art courtesy of the Permanent Collection, Montana State University School of Art, Bozeman:

Wild blue flax [*Linum lewisii*], Gallatin Valley, May 21, 1894–1912, by Frederica E. Marshall, watercolor, 6³/₈" x 10⁵/₈" [Blue flax is a Montana native plant, but does not appear in this volume.]

Buffaloberry [*Shepherdia argentea*], Gallatin Valley, October 1895, by Frederica E. Marshall, watercolor, 13¹/₄" x 10⁵/₈" [See page 119.]

Printed by BookCrafters, Chelsea, Michigan

97 98 99 00 01 02 5 4 3 2 1

Library of Congress Cataloging-in-Publication Data

Hart, Jeff.
 Montana native plants and early peoples/researched and written by Jeff Hart; illustrated by Jacqueline Moore.
 p. cm.
 Includes bibliographical references.
 ISBN 0-917298-29-2
 1. Indians of North America—Montana—Ethnobotany.
 2. Ethnobotany—Montana. I. Title
E78.M9H28 1992 92-20345
581.6'1'09786—dc20 CIP

Dedicated to Montana's First People

Contents

Contents

Acknowledgments

The research leading to the writing of this book would not have been possible without the generous financial help of various sponsors and contributors. I express my most sincere gratitude to the University of Montana Foundation, which provided most of the financial support. Additional contributors include the Department of Health, Education, and Welfare Title IV and VII programs on the Flathead Indian Reservation; the Smithsonian Institution; the Community Action Program in St. Ignatius; the Native American Studies Program at the University of Montana; and the Montana Johnson–O'Mally Program in Helena. The actual writing of the book is the direct result of the generous financial support of the Montana Bicentennial Administration. In particular, I would like to thank Director John Barrett, who first saw the uniqueness of this project.

The principal contributors, of course, were the elderly Indians themselves. Two Indians, both of whom are held in unquestionably high esteem among their tribal members, stand out in my mind as having contributed an inordinate amount of information. They also expressed a keen desire that it be preserved for future generations. They are the late Pete Beaverhead, noted Flathead medicine man, and Mary Fisher, a highly respected Cheyenne herbalist. Many others came forth to share what they knew. These included, among the Cheyenne: Wesley White Man, Ben Black Wolf, Elsie Wick, Harry Little Bird, Jimmy Little Bird, Mr. and Mrs. Charles White Dirt, Alex and Frances Black Horse, Jim Spear, Wilson Brady, Jose Limpy, Bessie Elk Shoulder, and Frank Walks

Last. Flathead contributors included: Agnus Vanderburg, Christine Woodcock, Annie Pierre, Larry Parker, Sophie and Bob Adams, and John Phillips. Those Kootenai Indians who shared their knowledge included: Joe and Mary Antiste, Adeline Mathias, Alex Left-hand, Agnus Auld, Pete Stasso, and Suzette Phillips. Crow contributors included: Micky Old Coyote, Hank Old Coyote, Allen Old Horn, and May Childs. The Gros Ventres to whom I talked were Luke Shortman and Madeline Colliflower. And finally, two Cree women, Mrs. Parker and Mrs. Turner, told me some of what they knew.

For their unfailing support and for such chores as editing and proofreading, I owe a debt of gratitude to Molly Hackett and to John Barrett and Anita Miller of the Montana Bicentennial Administration. My gratitude is extended also to Carolyn Mattern and Vivian Paladin of the Montana Historical Society. A special bouquet, of course, to Jacqueline Moore for her superb and accurate drawings which illuminate these pages.

Jeff Hart

The Montana Historical Society Press would also like to thank the following people for their help in preparing the manuscript to reprint in the new format: Carolyn Cain, Bonnie Heidel, Doris Hitt, Marge Jacobson, and Charlotte Thomas.

Introduction

Montana Native Plants and Early Peoples describes early uses of plants, especially for food and medicine, by Indian and early non-Indian inhabitants. Researched and written in 1975–76, this continues to be a timely topic. The past two decades have seen an awakening interest in the natural environment, including native medicines and wild foods. They have also seen a renewed interest and pride in our historical roots and ethnic heritage, especially native religions, folklore, and alternative lifestyles. The Bicentennial year of 1976 provided us with an opportunity to renew this appreciation. In this regard, this publication will, hopefully, provide a new look at Montana native plants—their uses, histories, and folklore.

Montana's Indians provided most of the information for this book. I traveled to most of the Indian reservations in the state in the early to mid seventies to research the role which plant life played in early Montana Indian culture, a study called ethnobotany. Within nearly every tribe there resided a diminishing number of elderly Indians, literally a handful, who were still knowledgeable about plant life and its original native uses. Each year some pass away to the other world, or "beyond the Milky Way," as the Cheyennes believed. With them dies tribal information resulting from generations of trial and error experimentation and religious insight. The elderly Indians' acceptance of my recording this information was generally enthusiastic, for most welcomed an opportunity to talk about a topic as interesting as plants. Many times it was difficult for these old people to remember, since in some cases they had not seen or used a particular plant for fifty years. But they did their best to supply information as

correctly as possible. In many cases their memories were astonishing. Mary Fisher, a Cheyenne woman, remembered sweet medicine (*Actaea rubra*) although it had been over a half century since she last collected it.

Although we think of wild game as the source of the Indians' primary sustenance in Montana, we often overlook the significant role played by plants. From the plant kingdom Indians gathered berries, seeds, and nuts; dug roots, bulbs, and rhizomes; brewed various teas; cut young green shoots to eat raw; peeled trees for their sweet inner barks, and found spices for their foods. From plants they got most of their medicines to heal the sick and injured. Some plants possessed magical properties to ward off malefic spirits or summon beneficent ones. In some they found scents which perfumed their lodges and sweathouses. Others they smoked in their pipes, made into shampoos and tonics for their hair, or used as insecticides for unwanted bugs. They discovered remedies for ailing horses, dyestuffs, and materials used in the manufacture of such items as bows, arrow shafts, and tipi poles. Many of these elderly Indians who were knowledgeable about plants wanted their information preserved. This book serves to meet that end.

Montana's early non-Indians—mountain men, fur trappers, and pioneers—used native plants, too. Sometimes they brought herbal remedies with them from distant places. This was true of the Lewis and Clark Expedition, whose goods included such foreign medicinal plants as rhubarb, ipecac, nutmeg, cloves, cinnamon, and peppermint. Other times they experimented with native plants.

Captain Meriwether Lewis, for example, was once afflicted by a great pain and fever which made him unable to walk. He had a companion break up some chokecherry twigs and boil them to make a "strong black decoction of astringent bitter taste." He drank a pint of this every hour. After four hours, he said, "every symptom of disorder forsook me. My fever abated. A gentle perspiration was produced and I had two complete nights rest."

On other occasions early non-Indians administered Indian-learned remedies. Bratton, another member of the Lewis and Clark Expedition, was suffering from rheumatism. With other supplies exhausted, they gave him an Indian sweatbath and horsemint tea. He later recovered. Pioneers who followed Lewis and Clark seldom wrote, and so there is unfortunately little recorded information. They did use a lot of alcohol, often in the

form of whiskey, as a medicine for whatever ailed them. And certainly they administered Indian-learned plant medicines. Countless others ate wild plant foods, especially when faced with starvation.

The plant medicines described in this book are given in the past tense, and with no advocacy intended. Many medicinal plants, in some concentrations, are poisonous. Other plants have certain parts edible and other parts poisonous. Reactions to plants vary among individual people, too. And in this age of increasing environmental awareness, it would be unwise to advocate indiscriminate gathering of certain plants which might become locally exterminated.

The scientific and common English names of plants follow the nomenclature of Dorn (1984) and Hitchcock and Cronquist (1973). Occasionally, literal translations of Native American names, such as "Indian ice cream," are used in place of English common names.

Jeff Hart
Missoula, Montana
September 1976

Subalpine Fir

Abies lasiocarpa (Hook.) Nutt.

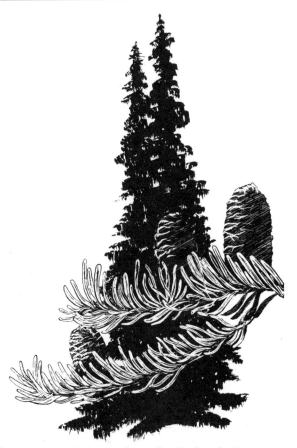

Montana Indians knew subalpine fir well. Flathead, Kootenai, Blackfeet, Crow, Cheyenne, and Cree found this stately, aromatic evergreen beneficial for personal adornment, medicine, incense, and for its powers of spiritual blessing and purity. Consider a hair tonic. Indians often enhanced the appearance of their long, sleek hair with a tonic from subalpine fir. Sophie Adams, a Flathead from Camas Prairie, has stated: "You dry and pound the needles and then mix it with grease from the deer. You use it for your hair before you comb it. It makes the hair nice and slick. My mother used it, and you could see the green color in it. It sure did smell good."

Flatheads made another concoction to make the hair grow longer; they mixed the needles of subalpine fir with the roots of lovage, *Ligusticum canbyi*, the leaves of buckbrush, *Ceanothus velutinus*, and the aboveground portion of pinedrops, *Pterospora andromeda*. Sophie Adams explained:

> You boil all that together and use it to rinse your hair after you have washed it. And everyday you also use it when you comb your hair. If your hair cracks on the ends they will quit after you use this, and you know that your hair is growing. You've got to use it for one whole year before you can tell that your hair has grown.

Native Americans employed subalpine fir for various medicinal purposes. They found it suitable for cuts, wounds, ulcers, sores, various skin infections, colds, coughs, and constipation. Pete Beaverhead, a Flathead, explained its use for skin diseases, especially when the skin has swellings: The needles are pounded into a very fine powder and then mixed with grease or marrow. This mixture is rubbed into the infected skin. But if the infection is open and runny, then only the very finely powdered needles are sprinkled on the infection. Flatheads pulverized the needles to make a baby powder; they used this on reddened skin caused by excessive urination. Some Indians used the gummy secretions on the bark as an antiseptic for wounds. Kootenai Indians used the gummy secretions for cuts and bruises. Mitch Small Salmon, a Flathead, administered the pounded needles, mixed with lard, to the bleeding gums of his mother-in-law. Indians used the needles as poultices for treatment of fevers and colds in the chest. They also made a tea from the needles and resinous blisters for colds. Crow Indians mixed crushed fir needles with an unidentified shrub which they brewed into a tea drunk for colds, coughs, and, in stronger concentrations, for constipation.

Non-Indians used a related species of fir, *Abies balsamea*, for healing. "Balsam traumatick" was part of the medicine chest of Lewis and Clark; they used it as a wound dressing. The 1890 *Materia Medica* claimed that the bark is "stimulant, diuretic, and anthelmintic, in larger doses laxative . . . and has been recommended in gonorrhoea, gleet and chronic inflammation of the bladder, etc."

Indians benefited from the sweet fragrance of subalpine fir. Flatheads often placed the needles on tops of stoves as incense, or arranged the boughs in a room for their aroma. They used the pulverized needles as a

body scent and perfumed articles of clothing such as shawls with them. Nez Percés put balsam with clothes to keep away insects; they also burned fir boughs in the sweathouse to impart a pleasant smell and elsewhere to purify the air and drive off unpleasant odors.

Subalpine fir brought blessings to Indians in yet more ways. Nez Percés plagued with bad spirits and ghosts hung branches on walls; they said bad spirits were afraid of them. They also burned fir to drive away woeful spirits and ghosts causing bad dreams. And, after a death, fir was burned in the house to fumigate it. Similarly, Cheyenne Indians used fir incense to chase away the spirits causing illness in people or to revive their spirits if near death. And Indians often used subalpine fir in various ceremonies: Cheyenne Sun Dancers incensed their bodies with its smoke in order to purify themselves; and, by burning fir, they sought to protect those who were afraid of thunder and to give them renewed confidence.

Description, Habitat, and Range

This evergreen varies in height, from prostrate shrubs at timberline to majestic, ninety-foot sentinels in subalpine forests. The grey bark is at first thin and smooth but with age becomes thick and rough; it is covered with resin-filled blisters. The flattened, linear, and blunt-tipped needles are shiny green above and whitish beneath. Its large purple cones stand erect on the branches.

Subalpine fir frequents mountain slopes and forested regions, from twenty-five hundred feet in elevation to timberline. It ranges from Alaska and the Yukon south through the Pacific Northwest, Idaho, and Montana, and to New Mexico and Arizona.

Other Common Names

Alpine fir. Balsam. Balsam fir. White balsam.

Boxelder

Acer negundo L.

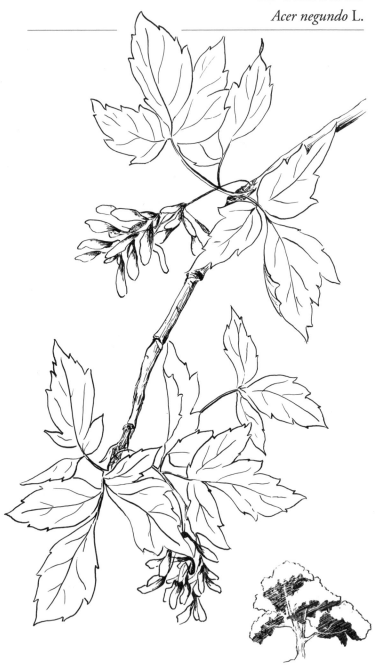

Few Montanans realize that we have a kind of maple from which Native Americans and pioneers tapped a sweet syrup. This is boxelder, a true maple found principally in the eastern sector of our state. Old-time Indians notched these trees in early spring when the sap began to flow; they drove in a wooden peg and allowed the sap to flow into birch bark pails or sacks made from young deer stomach. They made syrup by adding hot stones to containers of the sap, or by allowing it to freeze overnight and throwing away the frozen water which separated from the syrup at the bottom. More recently they have employed metal kettles for sap-boiling. Boiling boxelder sap is tedious; the shrinkage rate is an alarming thirty to one. Cheyennes relished a candy which they made by adding shavings from the inner side of animal hides to boxelder sap.

Indians discovered that boxelder burns hotter and maintains coals longer than do most other woods. For this reason, Cheyennes preferred its wood for cooking meat and in making spiritual medicines in which incense was burned. Additionally, they used the wood in making fires for the Sun Dance, where its long-lasting coals were constantly ready for lighting tobacco pipes. Sioux made charcoal from it for ceremonial painting and tattooing.

The large burls or knots found on the lower trunk provided Indians with a durable material for making bowls, dishes, pipestems, drums, and other items, but in time they discarded this natural material for products of European civilization. With the Cheyenne, however, boxelder wood took on a sacred character; they used it for ceremonial mixing of medicines and for eating special meals.

Description, Habitat, and Range

Boxelders are relatively small maples growing up to thirty-five or forty feet tall, with widely spreading branches. The leaves are divided into three to five leaflets, each measuring two to four inches long. The male and female flowers are borne on separate trees. The fruit is double, each part having a membranous wing which aids in dispersal. They are widely distributed throughout the United States. In Montana they are more commonly found along tributary streams in the eastern part of the state.

Alder

Alnus incana (L.) Moench

Native Americans made bright paints and dyes with which they colored themselves and their articles of clothing and manufacture. Some they obtained from mineral clays mixed with a grease or oil base; others they got from plants such as river alder. In our region, Blackfeet, Kootenai, Flathead, Nez Percé, and possibly other tribes boiled alder bark for its reddish brown or orange color. Flatheads commonly immersed their moccasins and feathers in boiled alder bark solution to obtain more brilliant colors. Some Flatheads even dyed their hair a flaming red with alder bark. It requires no added mordants to set the color, as do many other natural dyestuffs; apparently the tannin content in the bark serves this purpose.

For medicinal purposes, Blackfeet Indians drank the hot tea made from the bark for scrofula (tuberculosis of lymph glands, especially in the neck), and Kootenai women drank this tea to regulate their menstrual period.

Description, Habitat, and Range

River alder is a small tree standing up to twenty-five feet tall. It has smooth reddish brown or greyish brown bark. The leaves are simple, ovate-shaped, double toothed on the margins, and one and a half to four inches long. The flowers are small and arranged in conelike structures called catkins.

It frequents wet places, often bordering streams and lakes, from low to middle elevations. Its range extends from Alaska south to the Rocky Mountains, Cascades, Sierra Nevada, and to New Mexico and Baja, California.

Yarrow

Achillea millefolium L.

Yarrow is a medicinal wonder. North American natives and Old World herbalists used it in amazingly similar ways: it stopped bleeding from wounds and cuts; poulticed burns, boils, and open sores, cured fevers and colds; and alleviated toothaches. Certainly its most celebrated use was as a hemostatic, literally "blood stopper," for cuts and wounds. Flathead and Kootenai Indians crushed the leaves, either by chewing them or by mashing them in water, and then wrapped them around the wound. These Indians also believed that this herb acted as a disinfectant and promoted rapid healing. Mitch Small Salmon, a Flathead from Perma, said the following about this herb:

> I use the leaves when they are green. If you have a cut, you pull the green leaves off and just put it on the wound. After a few minutes, it takes the blood out and just stops the blood right there.

Mitch then told of a logging camp accident:

> I chopped myself right here on my hand with an ax. I pulled
> some yarrow leaves off and I kind of smashed it a little bit and
> put it on. Then, say about ten minutes, here comes my boss.
>
> "What's the matter with you, Mitch?"
> "I cut myself."
> "You'll have to go to camp."
> "No, I'll be all right now."
> "What do you have there on your hand?"
> "Grass." (Mitch didn't know the English name of the plant).
> "Grass?"
> "Yes."
> "All the grass is poison for wounds," replied the boss.
> "But this one isn't," I said, "We have known for a long time
> that it is good."

Meanwhile, Mitch told me, the blood had stopped flowing. By the next
day the wound was clean and white and well on its way to recovery. At
work the next day Mitch's boss asked:

> "How's your hand? Let me see . . . (taking a close
> look) . . . you're using the same thing!"
> "Yes, that's my medicine."

The medicinal properties of yarrow to which Mitch Small Salmon
referred, science attributes to an alkaloid chemical. Pharmacists have
extracted it from the plant and have named it achillein, after the scientific
name. They have found that this chemical actually reduces the clotting
time of blood in laboratory experiments, thus verifying its traditional
use. Not only the Flathead and Kootenai Indians knew of this property
of yarrow leaves, but other North American natives as well knew of its
value.

Even European herbalists knew of yarrow's ability to stop bleeding of
wounds and cuts, as the old European names "knight's milfoil" and
"soldier's woundwort" testify. It is said that Achilles—for whom this plant
is named—used it to stop bleeding wounds of soldiers at the famous
siege of Troy. Even the ancients knew it as *herba militaris*.

Crow Indians made a medicinal poultice from yarrow to treat burns,
boils, and open sores; they also made a salve from it by boiling the crushed
leaves and stems with goose grease which they then strained and added to
congealed fat.

A hot cup of tea made from the leaves proved a useful medicine for fevers and colds for Flathead and Cheyenne Indians. The beneficial value, in this particular situation, science attributes to its sudorific properties (causing one to sweat profusely). Man has long recognized the value of sweating to break fevers and to alleviate colds.

By boiling yarrow leaves, Flathead Indians made a solution for treatment of aching backs and legs. A story by Sophie Adams, a Flathead woman from Camas Prairie, reveals its medicinal use: "My uncle is eighty-six years old and he used this herb. He boils it and uses the water for his aching legs or aching anywhere in the body. And he's well. He is really old, but he walks really well from using yarrow."

The Kootenai, other Native American tribes, and some European groups used a decoction made from yarrow to wash sores and other skin problems. As Adeline Mathias, a Kootenai explained: "You can use it for many things. You can boil it and wash with it for sores and different things. You can also dry it, and the old timers once used it for cologne, perfume, or bath powder. They sewed little pouches in which the leaves were kept."

Yarrow is indeed an important medicinal herb. No doubt man has been healthier and his existence more pleasant because of its presence.

Description, Habitat, and Range

Yarrow has a white, flat-topped inflorescence blossom. It averages one to three feet in height. The leaves are generally three to four inches long and are intricately divided or dissected and thus fernlike in appearance. Many Indian tribes, including the Kootenai, call this plant "Chipmunk's tail" because the leaves bear a resemblance.

Yarrow is one of the most common plants in the world. It grows in dry to moderately moist soil in sunny areas from valley bottoms to mountain tops throughout North America as well as in the Old World.

Other Common Names

Milfoil. Soldier's woundwort. Knight's milfoil. Herba militaris. Sanguinary.

Baneberry

Actaea rubra (Ait.) Willd.

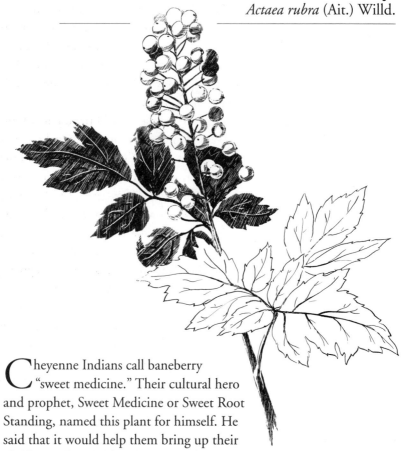

Cheyenne Indians call baneberry "sweet medicine." Their cultural hero and prophet, Sweet Medicine or Sweet Root Standing, named this plant for himself. He said that it would help them bring up their children. After childbirth, women drank tea made by boiling the root to increase milk flow for babies. They did not powder the root as they did with other medicinal plants, but merely cut it into small pieces before steeping in hot water. To prevent roots from losing some of their strength in the drying process, the Cheyenne scalded them in water in which fat had been boiled, leaving them covered with a thin film of grease. Cheyennes believed that their children would grow up to be of good mentality, strong, patient—everything which as been attributed to Sweet Medicine's standards. (Because the children now drink cows' milk, claimed the Cheyenne, they are now losing some of these qualities and becoming like cows).

Sweet Medicine reputedly lived 445 years with the Cheyenne. Upon his death, he transferred his sacred powers into this plant. To this day, Cheyenne keep this blessed root in Sacred Arrow, Sacred Hat, and Sun Dance bundles, thus benefiting from sweet medicine's sacred powers. It is the principal object in the chief's bundle, the one which Sweet Medicine gave to the Cheyenne after he returned from the holy mountain, Bear Butte. Of the Sacred Arrows, he said to them, "Don't forget me. This is my body I am giving you. Always think of me."

Cheyenne Indians performed what is called the "throwing it at him" ceremony with this sacred root. They perform it for most ritualistic acts in Sun Dance, Sacred Arrow, and Sacred Hat Ceremonies. In this holy rite, the priest-instructor bites a tiny fragment from the root and spits it upon his hands and those of other priests, thus throwing Sweet Medicine's power at them and blessing their hands for sacred tasks. As the priest does this, the others avert their eyes, because the sacred root would blind them if it touched their eyes. And to swallow the root would mean death. On one occasion, for instance, a Cheyenne named Elk River was giving the "throwing it at him" ceremony. By mistake he swallowed the juice; he soon died!

Cheyenne Indians occasionally have held blinding ceremonies with sacred sweet medicine root, purposely to blind their enemies. In this ceremony they chew the root and blow it in four directions, and then toward the enemies themselves. Unfortunately, the Cheyenne did not perform this rite when the Pawnee captured their Sacred Arrows.

Description, Habitat, and Range

Baneberry is a one- to three-foot perennial herb. Its leaves are divided into one- to three-inch long, thin, ovate, and sharply incised and toothed leaflets. Its white flowers form elongated clusters. The fruit is a glossy white or red berry.

Baneberry is found in moist, often shaded, places, from valleys to mountains, from Alberta south to California and New Mexico.

Other Common Names

Sweet medicine.

Serviceberry
Amelanchier alnifolia (Nutt.) Nutt. ex Roem.

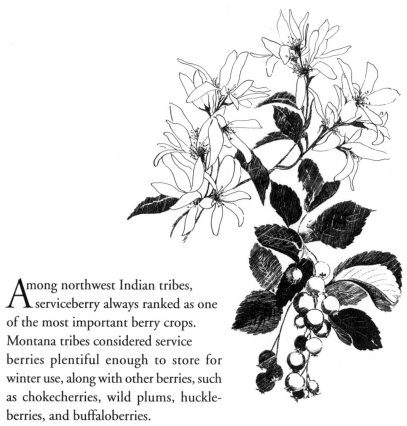

Among northwest Indian tribes, serviceberry always ranked as one of the most important berry crops. Montana tribes considered service berries plentiful enough to store for winter use, along with other berries, such as chokecherries, wild plums, huckleberries, and buffaloberries.

In preparation for storage, Indians sun dried the fruits, some whole, and others after being pounded and formed into patties. Flathead Indians powdered the leaves of horsemint, *Monarda fistulosa* and field mint, *Mentha arvensis*, and sprinkled the powder over the patties to keep flies away. Lewis and Clark mentioned that some serviceberry loaves weighed as much as ten or fifteen pounds.

The dried fruit was used in various ways. Sometimes it went into meat stews. Flathead Indians mixed the dried serviceberries with flour, sugar, and water to make a sweet pudding. Some tribes used dried serviceberries as an ingredient in pemmican; they pounded the berries

with dried buffalo meat, mixed them with fat, and formed them into little cakes. People now use the berries in countless other ways, especially with modern canning and freezing methods. Serviceberries make excellent jams, jellies, pies, and wine, and they also make delicious additions to pancakes and muffins.

Indians found the hard, weighty, and flexible stems a favorite material for arrow shafts. Pete Beaverhead, a Flathead, said that he preferred only the wood of Rocky Mountain maple, *Acer glabrum*, above that of serviceberry.

Flathead Indians used the wood of serviceberry in horse doctoring. Pete Beaverhead said that a sharpened stick stuck deeply into the swollen ankle of a horse could be used to drain blood and other liquids. Crow Indians used this wood for tipi stakes and tipi closure pins.

Serviceberry is a favorite with wildlife, too. Bear, grouse, and other species eat the berries. The young stems and leaves are palatable to a variety of game herbivores, including elk, deer, moose, and mountain sheep.

Description, Habitat, and Range

Serviceberry is a shrub or small tree, up to twenty feet tall. The white flowers appear before the leaves, usually about the first week in May. They are so numerous as to give the entire shrub a white color in contrast to the darker surrounding vegetation. The leaves are round, toothed above the middle, and measure one to two inches long. The dark blue to purple berries ripen generally in July—although this varies with altitude—and measure one-quarter to one-half inch in diameter.

There are many species of serviceberries in North America. This particular species is wide-ranging in the Northwest and is found from Alaska to California, east to Alberta, Nebraska, New Mexico, and Arizona. It is particularly abundant in the Rocky Mountain region, where it occurs in a variety of habitats: along stream banks and moist hillsides, in woods and open places, from sea level to subalpine terrain.

Other Common Names

Sarviceberry. Shadberry. Shadblow. Juneberry. Saskatoonberry.

Nodding Onion

Allium cernuum Roth

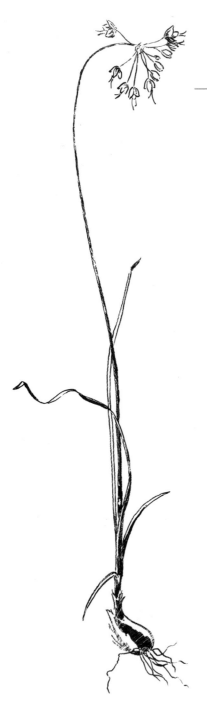

There are some three hundred species in the genus *Allium*, which includes onions, garlic, leeks, chives, and shallots. Nearly all are valuable as food, although some are notably better than others. None are poisonous.

The nodding onion is the most common onion species in our region; its bulbs served as a staple and condiment to Flathead, Kootenai, and certainly other tribes as well. Indians gathered these crisp bulbs from spring through early fall. They ate some raw but consumed most as an ingredient in soups, stews, and meat dishes.

Explorers and pioneers ate various kinds of onions. On General George Crook's 1876 starvation march down the Yellowstone River, the men partially subsisted on a certain species of wild onion. Lewis and Clark ate them in Montana, as did countless other mountain men and trappers.

Modern-day campers and hikers welcome the wild onion as a tasty addition to their camp diet, and more than once it has provided food for a lost hunter who could identify the dried, recurved stems which remain visible through late fall.

Wild animals—bears, ground squirrels, marmots—frequently dig these bulbs. But milk cows which happen to eat the foliage unfortunately have onion-flavored milk!

Description, Habitat, and Range

Nodding onion is six inches to two feet tall. Its long, grasslike leaves extend to nearly three-quarters the length of the plant. The most distinct feature is the pink flowers which are arranged in recurved or nodding clusters. The bulbs are one-half to three-quarter inches in diameter and have the characteristic "onion" odor.

This ubiquitous onion is found usually in open ground, generally from low to middle elevations on plains, hills, and mountain slopes. It ranges widely, clear across southern Canada, extending southward in the United States along the West Coast and Rocky Mountains, and in the east to Georgia.

Black Tree Lichen

Bryoria fremontii (Tuck.) Brodo & Hawksw.

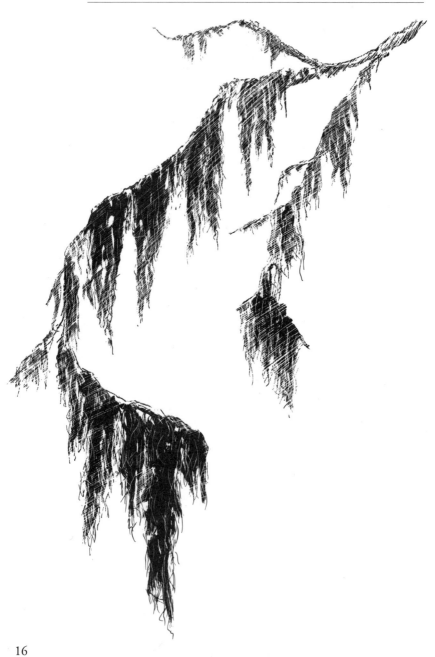

If you have ever seen this black, hairlike, and stringy growth hanging from various mountain conifers, certainly the last thing to come to your mind is food. Yet to many northwest Indians, black tree lichen not only gave them nourishment to ward off starvation but provided a sweet and delicious food.

Indians first cleaned and soaked black tree lichen in water before preparation. They baked it for one or two days in underground fire pits in a manner similar to the preparation of camas. In fact, they often cooked camas or Douglas onion with it. After baking, black tree lichen loses its coarse and stringy appearance, becoming a black, compact, and gelatinous mass. Either the Indians ate it like this, often with camas, or they sun dried and powdered it. This powder they mixed with powdered camas to sweeten it, then added water and boiled it to make a thick mush. In precontact times, Nez Percé Indians added grease for flavoring, but today they serve it with sugar and cream. Flathead Indians considered black tree lichen more of a luxury item than a staple; each family consumed about twenty-five pounds each year.

In winter months, during periods of scarcity, Kootenai Indians boiled black tree lichen with the stomach contents or even droppings from fool hen for flavoring. Nez Percé Indians believed black tree lichen good for upset stomach, indigestion, and diarrhea.

Description, Habitat, and Range

Black tree lichen is a non-flowering plant which consists of chestnut brown to almost black hairlike "branches." These measure about three to ten inches in length and can be seen dangling from conifers throughout the western states.

Indian Hemp

Apocynum cannabinum L.

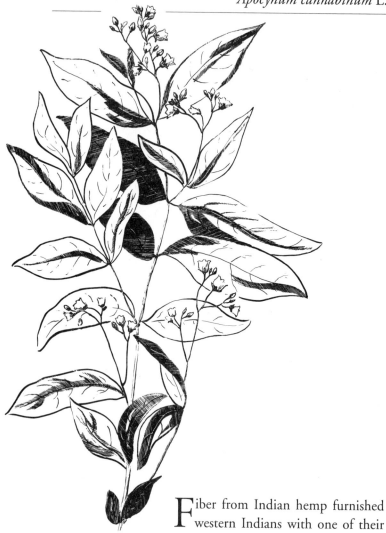

Fiber from Indian hemp furnished western Indians with one of their main sources of cordage. Nez Percé, for instance, rolled split and dried stalks on their legs to produce strands of fiber. They tied several of these strands—generally about three—to some object like a bush and twisted them to produce a rope, their only one until horsehair rope became available. Nez Percé used Indian hemp to make bags, while the Kootenai made twine and ropes from it.

Ethnologist H. H. Turney-High described how hemp was employed to make tipi covers: Kootenai Indians gathered hemp after the leaves had dropped, split the stalks, and scraped away the bark and pith with a sharp piece of wood. Then they wrapped the hemp into bundles, which they kept for a year. At that time the stalks were laid in long bunches, three inches in diameter, and plaited into ropes. After drying in the sun, the strands were unbraided and given another drying. From this they made a long, light rope which they rolled into a ball to serve as thread for sewing the lodge together. They laid the rest of the cured plants on the ground next to one another. With a bone needle, the thread was drawn tightly through each plant. Three sections or pieces of these shrubs were tied together to go around the tipi.

Kootenais chewed the tops of these plants and spat them into the eyes of their horses to relieve soreness. Early settlers employed the root as a tonic, febrifuge, and cathartic, although it was apparently poisonous in large doses. Charles Millspaugh, author of *American Medicinal Plants*, described dogbane, *Apocynum androsaemifolium*, as "an emetic without causing nausea, a cathartic, and quite a powerful diuretic and sudorific; it is also an expectorant and considered antisyphilitic." Indian hemp, *Apocynum cannabinum*, was widely used in early American medicine and was officially employed as a diuretic, diaphoretic, and expectorant. They found it valuable as a heart tonic, since it gave relief to dropsy resulting from heart failure, and they used it to treat hepatic cirrhosis. This medicine causes violent vomiting as well.

Description, Habitat, and Range

Indian hemp grows to heights of from one to three feet and has a milky, rubbery juice. Its leaves are from one to four inches long and are oppositely attached on the stems. The white flowers develop into pods from five to nine inches long, the seeds of which bear long hairs like those of the milkweed. Indian hemp grows in fields, thickets, and woodlands in plains and mountains. It is widespread across much of the United States and Canada.

Elk Thistle

Cirsium scariosum Nutt.

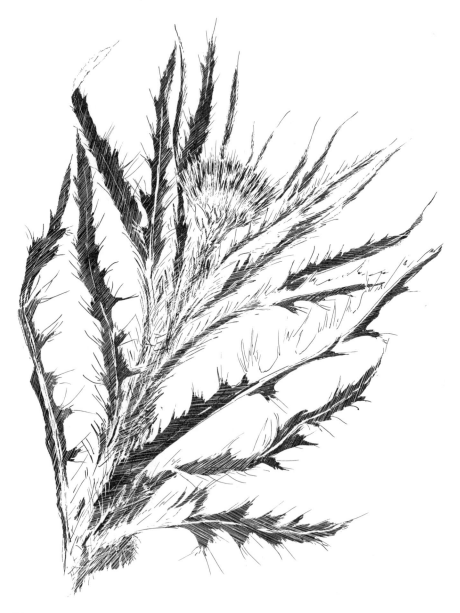

Truman Everts, among an 1870 party exploring Yellowstone Park, literally owed his life to thistle. While he was separated from the rest of his party, his horse threw him, breaking his spectacles. Horseless and near-sighted, he was unable to hunt game. Slowly starving to death, he feared his end was near. In desperation, he ate thistle roots, on which he subsisted until he was rescued nearly a month later.

Montana Indians relished eating young thistle stems, which they cut, peeled, and ate raw; they left alone older stems which toughened and hollowed with age. Nez Percé, Flathead, Kootenai, and other Montana Indians ate the roots, sometimes raw but usually baked in a fire pit for several hours to make them more palatable. Flatheads liked them so much, apparently, that they imposed a taboo to prevent people from picking too much. Obviously they applied this taboo to their native species, not to the introduced common thistle, *Cirsium vulgare*, which has become an abundant and noxious weed.

John Pelkoe, an elderly Flathead from Camas Prairie, remembers that when he was a small boy the first common thistles came into the region along railroad tracks; he figured that the seeds must have fallen from the railroad cars. The Kootenai Indians believed that Frenchmen introduced this thistle and therefore called it "Frenchman" or "old man."

Description, Habitat, and Range

Elk thistle has thick, spiny, and unbranched succulent stems rising two to four feet in height. The white to purple flower heads are about one or two inches across and are clustered at the top of the plant. The leaves are deeply dissected or toothed.

It is widespread in mountain meadows and other moist places in the western United States. There are about twenty species of thistle in the Rocky Mountains. These are poorly understood taxonomically.

Camas

Camassia quamash (Pursh) Greene

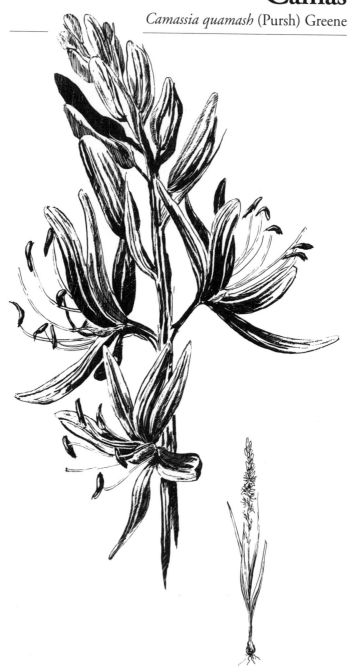

I magine a plant whose blue flowers so densely colored moist northwest meadows that early travelers occasionally mistook these places for distant lakes. This was camas, a lilylike plant whose underground bulbs Indians fire baked to provide a sweet and nutritious staple. For some western Indians it constituted the single most important food item before the whites came, and it was an item of considerable trade for many others. Father Pierre-Jean De Smet enthusiastically described it as the "queen root of this clime."

Indians told various stories to explain the origin of camas. Kootenais claimed that Coyote, the leading cultural hero of the region, went visiting, and after calling on Kingfisher, visited Moose. To accommodate his guest, "Moose slapped his backsides, and camas came out." He then put it into a kettle and gave it to Coyote for food. Other Kootenais believed that places where Coyote defecated became camas prairies, an allusion to the similarity of feces of many ungulates to the dark, cooked camas bulbs. Flatheads credited Coyote with distributing camas "here and there." But by the time he reached Hot Springs, Montana, he had only small camas bulbs left in his bags, thus explaining why camas grows to such a small size there today.

Flatheads described where they got camas by telling this story:

> The Coyote had five sons with his wife, and lived in a lodge a great distance from any other habitation. One morning he took his youngest son and started to visit Elk, who also had five sons. When, after a long journey, they arrived at the Elk's lodge, they found it empty and no signs of anything to eat. Then the Coyote said to his son, "I do not like this, not having anything to eat after such a long walk." Soon the Elk returned and after welcoming his visitors, stooped and picked up a sharp stick with which he began to tear open his hips to dig out some Kamass roots. The Elk then said, "Eat some Kamass roots, they are good; I always provide myself in this way when I am away from home and get very hungry." "What," said the Coyote, "do you expect me to eat dung?" "That is not dung," said Elk, "but Kamass roots." Then the Coyote picked up one of them and after nibbling at it cautiously, discovered it to be very good, whereupon he and his son filled their bellies with Kamass.
>
> When the Coyote was about to depart, he said to the Elk, "Come and see me tomorrow, and see how I live." "Yes," responded the Elk, "I will come to see you tomorrow."

Next morning the Elk took his youngest son and set out for the Coyote's lodge which he reached after a long journey. After the Elk was welcomed, the Coyote took a sharpened stick, as he had seen the Elk do, and commenced to tear his flesh in a painful manner, when the Elk cried, "Stop! Stop! Do not tear yourself so: I do not think you ever tried that before. It is my practice to do that when I am away from home and get hungry, so let me provide the Kamass roots this time." "That is just what I wanted you to do for me," said the Coyote, and handing the stick to the Elk, they soon had enough Kamass for all, and after they had filled their bellies, the Elk and his son left for home.

Although early whites found camas growing abundantly in some localities, they only occasionally consumed its edible bulbs. Perhaps Lewis and Clark were the first white men to encounter and use it. Captain Clark reported in his journal on October 21, 1805: "Collins made some excellent beer of Pasheco quarmash bread of roots which was very good." In 1806 the expedition obtained a great deal of quamash near Potomac, northeast of present Missoula. They also mentioned several small plains of camas in the Bitterroot Valley, and near Lolo Hot Springs. They apparently were the first to describe Indians baking camas, too, this among the Nez Percé.

Nathaniel Wyeth reported on April 24, 1833, that "the Flathead Valley abounds with the finest kamas I have seen yet. As provisions are scarce in the camp the women dug much of it." Naturalist T. Nuttall in 1834 reported that camas is "in such abundance as to give name to particular plains and communicate a general blue tint to many thousands of verdant acres. The root, which is wholesome to almost all palates, is collected by the aborigines in large quantities, and constitutes their great substitute for the Cerealia of civilized life."

Members of the 1854 Mullan Road Survey ate camas, while Major John Owen stated in his November 8, 1858, journal: "Struck Sun River near its [Mouth?] went to bed after supper of Camash and berries which one of the Indians happened to have with him."

Father Anthony Ravalli, the great Jesuit missionary-physician, wrote: "I once made two gallons of splendid alcohol from about three bushels of camas by fermenting, and with the aid of a zigzag worm of tin for a still. I took great care that the Indians should not know of this, so as to learn the art."

Father Palladino later assured us that Father Ravalli's alcohol was for

medicinal purposes, but we may never really know. Elliott Coues suggested a reason why whites infrequently ate camas: "Taken in sufficient quantity, camas is both emetic and purgative to those who are unaccustomed to eat it." Father Nicholas Point added that camas "is eaten with pleasure, but its digestion is accompanied by very disagreeable effects for those who do not like strong odors or the sound that accompanies them."

Camas grows generally west of the Continental Divide in Montana, an area moderated by warm Pacific winds. But it does occur in a few localities on the east slope of the divide, where Blackfeet dug it in northern Montana, and where Flatheads collected it in the Big Hole Valley. Indians probably gathered it in other localities as well, since it reportedly grows along various tributaries of the Missouri and Yellowstone Rivers in eastern Montana. Camas once grew in numerous moist meadows west of the Continental Divide, and where abundant, Indians avidly dug it. In historic Pend d'Oreille and Kootenai territories, camas grew at Hot Springs, west of Flathead Lake, near Thompson Falls, in Glacier Park, along the South Fork of the Flathead River, on the Tobacco Plains, and in Rexford, Libby, Pleasant Valley, and Kalispell.

In recent times, Flathead Indians preferred digging camas at two places: Evaro Hill and Potomac. Of these two, the spot at Potomac provided them with the most abundant supply. Pend d'Oreille Indians favored digging in the Hot Springs area. Although camas at the Camas Prairie near Hot Springs grew smaller in size, Indians often preferred the bulbs from there because they were sweeter. Other locales where camas once flourished include: places in the Bitterroot Valley, such as Lake Como, Lolo Pass, Lolo Hot Springs, along Ninemile Creek, along the Little Blackfoot River, near Butte, near Sunset, and places in the Swan Valley, including Seeley, Placid, and Moose Lakes.

The Kootenai told a story explaining the absence of camas in their north country:

> A Columbian Lakes man travelled south and married a woman where in whose country camas grew. She came north with him to live but not liking it there, returned to her home. On the way back the woman threw away bitterroot both at St. Eugene [Cranbrook] and at Tobacco Plains . . . so that it is to be found at these places today. She was so fond of camas, however, that she kept this plant until she arrived in her own country.

Due to differences in quality and abundance, camas constituted an item of considerable trade among various Indian groups. Thus, Shoshoni traded it to Nez Percé; Nez Percé traded it to Gros Ventre and Crow; Upper Pend d'Oreille traded it to Kootenai; Kootenai traded it to Blackfeet, and so on. One reason why Flatheads traded for it with Nez Percé, for instance, was that they preferred its larger size and superior flavor to their own.

Indians generally dug camas bulbs in June, but this varied from one place to another and depended upon altitude and seasonal weather conditions, especially precipitation and temperature. More specifically, we learn of the proper time to collect camas from the early western botanical explorer, C. A. Geyer: "The digging of Gamass [sic] takes place as soon as the lower half of the flowers on the raceme begin to fade, or better, when the time of flowering has already passed." Others claimed that the bulbs were sweetest at this time, contained the maximum amount of stored energy, and peeled more easily. At this time, family groups splintered from the main tribe for their accustomed digging grounds. The number of people encamped at a particular camas prairie depended upon the abundance of camas—from one to several families at smaller prairies to entire tribes and more at the larger ones. Each family unit usually returned to the same area each year, but there were no family rights to these grounds; such rights generally rested with the bands.

Although it was hard work, digging camas was a gala affair. The activities of men and women differed, as indicated by this passage from botanist Geyer:

> The digging of the Gamass bulb is a feast for old and young amongst the Indians; a sort of picnic which is spoken of throughout the whole year. In different neighbouring tribes meet on the same plain and mostly at the same time at the same spot where their forefathers met. Here the old men talk over their long tales of olden times, the young relate hunting adventures of the last winter, and pass most of their time in play and gaming; while on the women alone, young and old, rest the whole labor of gathering that indispensable food. They, especially the young women, vie with each other in collecting the greatest possible quantity and best quality of Gamass, because their fame for future good wives will depend much on the activity and industry they show here; the young men will

not overlook these merits, and many a marriage is closed here after the Gamass are brought home. I saw a young woman at the Skitsoe village, who had collected and prepared sixty sacks of good Gamass, each sack containing $1^1/_5$ bushel; she was spoken of in the best terms throughout the village.

To remove camas bulbs from the heavy meadow turf, women preferred using elk antler digging sticks. However, they sometimes used fire-hardened wooden sticks made from hawthorn, serviceberry, and other woody materials, with horn, antler, or wooden transverse handles. Eventually, metal digging implements replaced other tools. To obtain camas, they stabbed these digging sticks within about six or eight inches of the plant and worked the digger back and forth until the soil was loosened enough to remove the bulb. By the 1900s some Indians used plows to make long furrows across the camas meadows; women followed behind, collecting larger quantities of upturned camas bulbs than ever before. Upon digging the bulbs, the women placed them into baskets of cedar bark or, in later times, leather bags of Nez Percé design.

Indians characteristically cooked camas in earth ovens before eating or storing it. This method of preparation is generally the same throughout the Northwest, and what is described here pertains to most Indian groups. They cooked camas at digging camps, especially on higher ground among the adjacent pines, which furnished firewood. In the 1840s, Father Nicholas Point, artist-priest, painted one such scene depicting camas preparation among a grove of pines.

Although men did assist in gathering firewood, they did not go near the pits when in use "lest bad luck and famine overtake all," warned some Flatheads. Likewise, Kootenai men "were not permitted near the roasting pits, else the camas would not be roasted properly," and Blackfeet men "were supposed to keep at some distance from the cooking pits." This taboo held with most tribes and was probably just a means to keep men out of the way.

Because Indian families often returned to the same camas camp each year, they naturally tended to re-use the same pits, but occasionally they had to dig new pits. To do this they employed digging sticks, flat rocks, or wide pieces of wood to remove the soil. Interestingly, early camas pits were circular in shape, but the later ones were rectangular, an apparent European influence. The pits varied in size, too, depending upon the

quantity of camas to be cooked. In recent times they have become smaller, an indication of the decreasing importance of camas.

The first step in cooking camas was to preheat the earth oven by building a fire in it from dry ponderosa pine. Women placed small river boulders, each generally about five inches in diameter, either on top of the firewood, beneath it, or in alternating layers. After the stones became sufficiently hot, they placed earth or a layer of vegetation over the stones. These plants included slough grass, alder branches, balsamroot leaves, skunk cabbage leaves, and willow. Next they placed camas bulbs on top of the vegetation. In recent times, however, they have put camas into cloth bags before adding it to the fire.

Several women often pooled their camas and cooked it together. Sometimes they added black tree moss (really the lichen *Bryoria*), but normally they cooked camas with the Douglas onion, *Allium douglasii*, which they called "small camas." Water poured over the green vegetation prevented the camas from burning. They poured the water through a hollow tube of willow bark or through a hole made by twisting a stick previously thrust into the pit. Then they placed a layer of bark over this and finally dirt.

They built a fire on top of the earthen oven and allowed it to burn from twelve to seventy hours, depending upon the quantity of bulbs in the pit. Cooking camas required a great deal of skill, care, and patience. With the Flatheads, success at this undertaking was a mark of distinction for the women. If a Blackfoot woman burned any bulbs, "ill-luck would most certainly befall the woman to whom they belonged . . . some of her relatives would die soon."

Blackfeet determined whether camas was done by the odor that arose from the pit. Nez Percés would open the oven after forty-eight hours and judge by the color of the bulbs, which became dark brown or black when completely baked. Indians avidly ate the bulbs upon removal from the pit. Cooked camas is moist and soft, but retains its original shape. Father De Smet said it had "a consistency of Jujube."

Indians allowed about a week to dry the camas bulbs which they could not immediately eat. Some they stored whole for future use, others they squeezed into little cakes for storage. And they used stone pestles for pulverizing camas on flat rocks and formed them into round loaves for storage. They also powdered the camas-moss combination, since it would

otherwise soon have become a sticky, gelatinous mass.

If kept dry, camas has remarkable storage qualities and could be preserved almost indefinitely. In 1847, David Thompson wrote: "A short exposure to the sun dried them sufficiently to keep for years. I have some by me which were dug up in 1811 and are now thirty six years old and are in good preservation. I showed them to the late Lord Metcalfe who ate two of them, and found them something like bread; but although in good preservation, they in two years lost their fine aromatic smell."

Flatheads stored the bulbs on platforms in trees or on limbs hanging from trees. In later years they stored camas in leather parfleche bags kept on platforms mounted on tipilike frames. Other Indians used storage pits.

Indians prepared camas in other ways as well. When insufficient time prevented fire-baking, Flatheads boiled camas in removable, sewn and fitted bison bags which they placed into a pit. They filled the pit with water, which they brought to a boil by submerging stones heated in a nearby fire. In permanent campgrounds they used large wooden pots made by hollowing out large, pitchy burls of pine, fir, or larch.

Flatheads boiled camas to make a sweet-tasting hot beverage, drunk much like coffee. They also prized a soup made by simmering the camas-moss combination in blood. Fresh meat broth often provided a favorite medium in which to boil camas. Recently they have boiled camas with commercial flour to produce a thick gravy.

Before the introduction of sugar, camas constituted the principal sweetening agent for many northwest Indians. Even the name "camas," which is borrowed from the Chinook trade jargon, can be traced back to *chamas*, a Nootka word meaning "sweet." Many observers have claimed camas to be sweet and nutritious, but until recently they gave no supporting evidence. Recent experiments at the University of Michigan have provided us with a clearer understanding of its biochemistry. Contrary to popular belief, camas contains no starch. Much of it is insulin, a non-reducing sugar which the human body cannot digest. These Michigan experiments bear out what has long been suspected: important chemical changes occur during the traditional Indian baking process. These researchers found that insulin breaks down to fructose, a sugar which the human body can digest. The concentration of fructose in cooked camas is fairly high, 32.9 percent wet weight or 43 percent dry weight.

Flatheads commemorated camas with two dances. They held one ceremony in January in which they prayed for an abundance of vegetable foods in spring. This dance was a favorite time for marrying, merriment, riotous laughter, and other happy times. Both men and women danced alternately in the same circle. The Camas Dance lasted four days and initiated the midwinter festival, of which half was the Bluejay Dance. The other Flathead Camas Dance, held in summer, was a minor ceremony, held immediately after gathering the root, and it was of variable duration. Men and women and children danced clockwise in a circle, singing special songs and dancing rather than singing individual spirit songs.

Description, Habitat, and Range

Camas is a one- to two-foot tall, lilylike plant whose brilliant blue flowers are clustered in racemes at the tip of the flowering stalks. The onionlike bulbs are covered with blackish coats but are white inside. The grasslike leaves rise almost to the height of the flowering stalk.

Camas grows in moist meadows, especially those which become dry by late spring. It occurs from British Columbia east to southwest Alberta, Montana, Wyoming, and Utah.

Oregon Grape

Mahonia repens (Lindl.) G. Don.

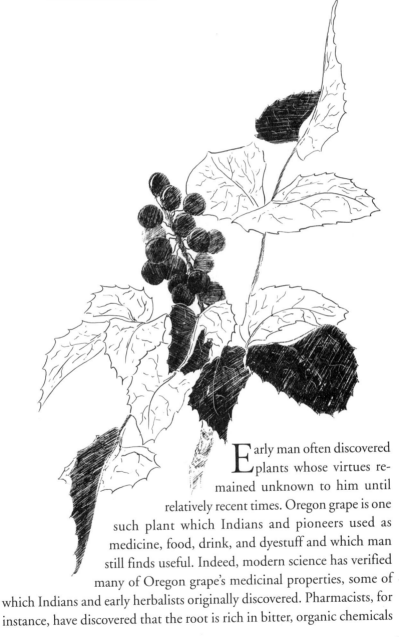

Early man often discovered plants whose virtues remained unknown to him until relatively recent times. Oregon grape is one such plant which Indians and pioneers used as medicine, food, drink, and dyestuff and which man still finds useful. Indeed, modern science has verified many of Oregon grape's medicinal properties, some of which Indians and early herbalists originally discovered. Pharmacists, for instance, have discovered that the root is rich in bitter, organic chemicals

known as alkaloids. They have isolated one of the more interesting alkaloids from this plant and have named it berberine, after the specie's previous generic name *Berberis*. They have discovered that it stimulates involuntary muscles.

This may explain the reasoning behind the Flathead use of the tea made from the roots to facilitate the delivery of the placenta, but it seems inconsistent that they used it as a cough medicine, since one would think that a muscle stimulant might make one cough all the more! Indians and pioneers knew of Oregon grape's antiseptic properties. Flatheads, for example, used it to clean wounds and cuts. Pete Beaverhead, a Flathead medicine man, said that the roots were cleaned, crushed, and placed on the wound with a clean cloth. The dressing was changed three times a day, and the wound would heal in about three days. Flatheads seemingly chose an effective medicine in Oregon grape in this regard, as the *National Formulary* states its antiseptic and antibacterial properties. Kootenai Indians drank this tea to "enrich" their blood, and early American folk herbalists recognized it as a blood tonic.

Native Americans had their special medicines for treatment of bothersome venereal diseases, and Oregon grape was one of their favorites. Flathead Indians drank the tea made from the roots for both gonorrhea and syphilis. Non-Indians also found it useful in this regard. The *National Standard Dispensatory*, a reference book of pharmaceutical plants, notes its early use in treating syphilis.

Some people used Oregon grape as a kidney medicine, apparently successfully. According to Adeline Mathias, a Kootenai, "You can cook the roots, make a tea, and drink it if you have kidney troubles." Early pioneers drank this tea for kidney troubles, and the *National Standard Dispensatory* still verifies its use as a stimulant and diuretic to the kidneys.

Feverish patients drank Oregon grape root tea for relief, and again, the *National Standard Dispensatory* states this use in early American medicine. Others drank it for stomach troubles, and the Flatheads used it to treat rheumatism and as a contraceptive. A Kootenai, Mary Antiste, drank the tea as an appetizer, stating that if she drank about three cups of it, her appetite improved.

The *National Standard Dispensatory* lists other uses of Oregon grape as a tonic, stimulant, antiperiodic, and antiscorbutic, and as a treatment for dyspepsia, diarrhea, dysentery, psoriasis, eczema, and chronic uterine

diseases, but warns that an overdose can be fatal.

Oregon grape berries are edible, but most people find them sour. Bob Adams, a Flathead from Camas Prairie, said that while in the woods, he roasted them in a fire and ate them after they had cooled. After whites introduced sugar into the region, Indians used Oregon grape berries more extensively. Flathead and Kootenai Indians mashed them in a bowl and added sugar and milk for a tasty dessert. Today Indians and non-Indians make delicious jams and jellies from them. And to make a refreshing drink, some tribes crushed the berries and mixed them with sugar and water.

Finally, a brilliant yellow dye can be made from the roots. The color comes from the medicinal alkaloid berberine and can be seen if the bark is scraped off. The dye is made by boiling the shredded bark.

Description, Habitat, and Range

Oregon grape is not likely to be confused with many other plants. It is a small evergreen shrub seldom more than a foot tall. It has shiny, spine-tipped, hollylike leaves that turn from green to deep red in autumn. The beautiful cluster of yellow flowers develops into dark bluish-purple berries by late summer. The wood and inner bark of the root are yellow.

This small shrub can be found in the lower foothills and wooded mountain slopes in the northern Rocky Mountains.

Other Common Names

Barberry. Holly-grape. Mahonia.

Wild Rose

Rosa spp.

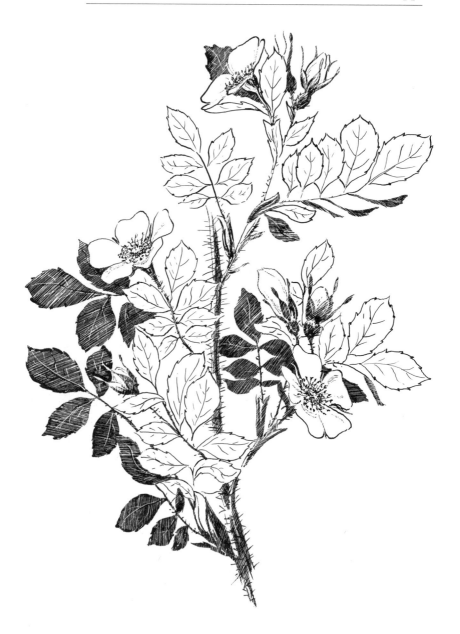

Coyote, cultural hero and trickster of many Indian tribes, once came upon a rosebush and decided to eat one of the bright red berries. As a consequence, his anus began to itch. Coyote couldn't resist the urge to scratch and immediately commenced to relieve his problem. He scratched so much that he began to bleed; in fact, according to legend, he soon bled to death. Whether Coyote really died from this experience is hard to say. But the message of the story conveys the reluctance of the Indians to accept the rosehip as a food source. Indeed, it seems probable that Indians often avoided "Coyote's berry."

Some Indians occasionally used rosehips for food, yet other Cheyennes cautioned not to eat them too freely, since they could cause the itchy experiences of Coyote. Most likely, Indians consumed rosehips during hard winters when famine threatened. Since they remained on the bush for much of the winter, they could be gathered as a hedge against starvation. The early fur trapper, Alexander Ross, snowbound near Sula, Montana, in March 1824, reported that the women gathered berries, a likely reference to rosehips. Nez Percé Indians similarly regarded them as a last resort against famine.

Europeans and Americans have long appreciated the food value of rosehips, which are exceedingly high in vitamin C and A and therefore valued for their antiscorbutic qualities. In fact, during World War II Europeans collected great quantities of them, especially in England and the Scandinavian countries. In 1943 alone, Britons collected some five tons, using the harvest to make National Rosehip syrup.

There are more exciting ways to prepare rosehips, only the lack of imagination restricts the cook. Have you ever tried rosehip jams, purees, or soups? One can even powder the dried hips and use them as a flavoring ingredient. Even the blossoms are a good food source; folk herbalist Euell Gibbons relished uncooked rose petal jam, which he claimed was very easy to make.

Most Indians of our region extolled the medicinal virtues of wild rose. To many, the rose was a celebrated remedy for diarrhea and stomach maladies. Cheyenne, Kootenai, Gros Ventre, Blackfeet, and Crow Indians drank a tea brewed from the stem or root bark. Cheyennes and Flatheads believed the wild rose beneficial for eye sores from exposure to snow; for relief they made an eyewash by boiling the petals, stem bark, or root bark. To reduce swelling, Crow Indians made a hot compress from a

solution resulting from boiling the crushed roots. They also sniffed the vapor from this for nose bleeding, drank it for mouth bleeding, and gargled and swallowed some of it for tonsillitis and sore throat.

Non-Indians have seldom used the wild rose for medicinal purposes. The blossoms of the cultivated rose are distilled for their essential oil; it is used to make perfume and in medicine serves as a flavoring agent. The 1890 *Organic Materia Medica* described the red blossoms of a cultivated species as a pleasant astringent for ulcers of the mouth, ears, anus, and for inflammation of the eyes.

Some Indians believed the wild rose to possess properties woeful to bad spirits. Nez Percés hung sprigs of it on cradleboards to keep ghosts away from babies; these same sprigs, they believed, drove away ghosts of dead persons. Flatheads hung rose stems on walls of haunted houses and lined graves with stems to prevent the dead from howling.

Description, Habitat, and Range

There are several species of wild roses in Montana. Generally they are difficult to identify, even for the trained botanist. Most are characterized as shrubs with prickly or bristly, usually upright, stems. The leaves are compound, with three or more divisions. The flowers are usually large and showy, rose colored and with five petals. The fleshy, "applelike" fruit, called the rosehip, is vase shaped.

Wild roses are widespread in North America, occurring in thickets, woods, streamsides, and mountain slopes, and even in prairie regions.

Balsamroot

Balsamorhiza sagittata (Pursh) Nutt.

Flathead, Kootenai, and Nez Percé Indians peeled balsamroot's young, immature flower stems and ate the tender inner portion raw, like celery. They apparently did not eat the stalk supporting the leaf (the petiole) as food. Some Indians ate the tough, woody roots. To make them more palatable, Flatheads baked them in a fire pit, like camas, for at least three days. Nez Percés ate the seed, which are similar to sunflower seeds. They roasted and ground them, then added grease and formed the mixture into little balls.

Some used balsamroot for medicinal purposes. Flatheads used the large, coarse leaves as a poultice for burns, while the Kootenai boiled the roots and applied the infusion as a poultice for wounds, cuts, and bruises. Flatheads drank the tea brewed from the roots for tuberculosis, whooping cough, increased urine, and as a cathartic.

Description, Habitat, and Range

Balsamroot is a coarse, hairy perennial herb arising from a deep-seated, woody root. Its leaves are long petioled, triangular shaped, and measure up to a foot or more in length. The yellow, sunflower-like blossoms are from two to four inches across. It is abundant in dry prairies and foothills throughout western North America.

Red-Osier Dogwood
Cornus stolonifera Michx.

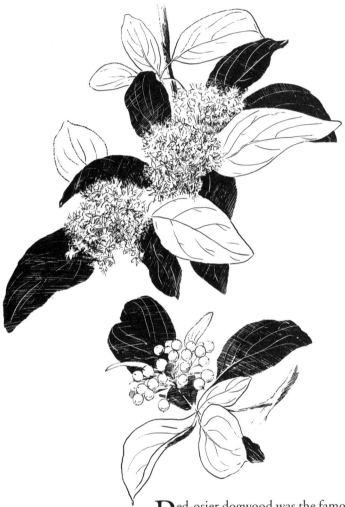

Red-osier dogwood was the famous "Bois Rouge" of the voyageurs and "red willow" of the Indians. Some Indians, especially Plains inhabitants, refer to it as kinnikinnick, a borrowed Algonkian word meaning "that which is mixed," in reference to its use as a smoking mixture. Kinnikinnick, however, is a confusing name because it also applies to bearberry, *Arctostaphylos uva-ursi.*

Montana Indians knew red-osier dogwood best for its inner bark used as a mixture for ceremonial and religious pipe smoking. To prepare the mixture, Indians would first remove the red outer bark from the fire-warmed stems. Then they partially scraped the white inner bark so that long ribbons of it still clung to the stems. These were roasted over the fire until dry. Finally, Indians would mix the ribbons with tobacco and, possibly, kinnikinnick.

Flathead and Kootenai peoples occasionally ate the white, sour-tasting berries, although they did not consider them to be a major food item. These Indians occasionally ate the berries raw, but they normally mixed them with serviceberries and added sugar. This dish they called "sweet and sour," after the sweet-tasting serviceberries and the sour-tasting dogwood berries.

Indians manufactured various goods from dogwood branches. Flatheads constructed arrows from them; so did the Cheyenne Indians. Blackfeet Indians covered split beaver teeth with dogwood bark to make gambling wheels, and Kootenai trappers made pelt-stretchers and other small items from the wood. Crow Indians manufactured drumsticks, tipi stakes, tipi pins, forks for sweatlodge rocks, and other tools from dogwood branches. Other Indians made fishnets from the twisted branches.

Description, Habitat, and Range

This red-stemmed dogwood stands up to fifteen feet in height. Its leaves are from one to three inches long and are arranged in pairs on the stems. Its flowers are white and are grouped into flat-topped clusters. The berries are one-quarter to one-eighth inch in diameter and are white to bluish in color. They ripen in late summer.

Red-osier dogwood is a shrub of meadows, boggy areas, and streambanks from valley bottoms to seven thousand feet in elevation. Its range is impressive, extending across much of temperate North America.

Other Common Names

Cornel. Kinnikinnick. Red-stemmed dogwood. Red willow.

Western Larch

Larix occidentalis Nutt.

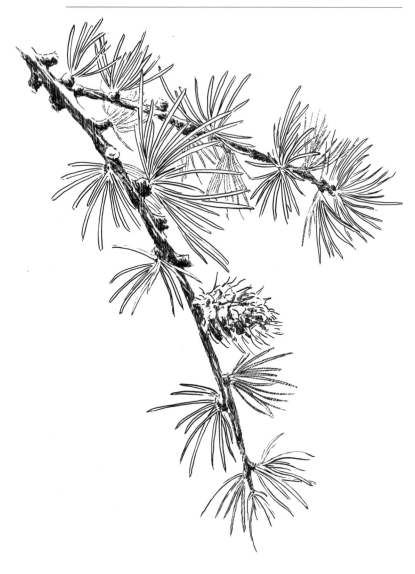

Flathead and Kootenai Indians prized a sweet syrup which they got from larch trees. To obtain this syrup, they hollowed out a cavity in the trunk, allowing about one gallon of the sap to accumulate. Normal evaporation concentrated the syrup, making it considerably sweeter. They gathered this once or twice a year, depending upon the individual tree, and recognized that certain trees produced a sweeter sap flow than others. Some Flatheads warned that eating too much of it "cleans you out." Flatheads also peeled the spring bark for its edible cambium layer and chewed the solidified pitch as gum.

Northern Rocky Mountain Indians discovered medicinal properties in larch. Kootenais applied the gum on cuts and bruises; they also drank a tea made from its bark for tuberculosis, while Nez Percés drank it for colds and coughs and chewed the sap for sore throat.

Kootenais preferred rotten larch wood for smoking buckskins, claiming they came out neither too dark nor too light. Nez Percés found larch wood suitable for making bowls, while others used it as fuel.

Kootenai Indians were unique in that they were the only tribe west of the Continental Divide who practiced the religious Sun Dance. They chose the larch for their center pole, while tribes to the east chose cottonwood.

Description, Habitat, and Range

Western larch is a large forest tree, reaching heights of from one hundred to two hundred feet. Mature trees have deeply furrowed and flaky cinnamon bark; this often becomes very thick with larger trees. Larch needles are from one to two inches long, pale green, and grouped in bunches of fifteen to thirty. Unlike other conifers, larch is deciduous, turning gold in the fall and then losing its needles. Larch cones are small, measuring only one to one and a half inches long.

Larch grows on mid-mountain valleys and slopes which are relatively moist, from British Columbia southward to Oregon, Washington, Idaho, and Montana. It is bounded by the Cascade crest on the west and the Rocky Mountain Continental Divide on the east.

Pineapple Weed

Matricaria matricarioides (Less.) Porter

Indians found pineapple weed a deserving addition to their *materia medica*, but they also employed it as a perfume, a bug repellent, and occasionally for food. Indians brewed a medicinal tea from this aromatic herb. Flatheads drank it for colds, especially recommending it for children because the taste was pleasantly mild. They also used it for upset stomach and diarrhea. Others drank the tea to induce perspiration to break fever. The women preferred pineapple weed tea for their own complaints. They drank it to build up their blood at childbirth and to aid in delivering the placenta. Young girls experiencing their first menstrual cramps drank it for relief.

Flathead Indians used pineapple weed to preserve meat and berries. They dried and pulverized the plant, then sprinkled it over meat or berries in alternate layers. This was especially important because fire or sun drying did not always fully protect the meat from spoilage.

Some used the sweet fragrance of pineapple weed as a perfume. Kootenai Indians placed the dried and powdered leaves in little pouches to concentrate the aroma, while the Cheyenne preferred mixing it with fir or sweetgrass. Suzette Phillips, a Kootenay who lived in Canada, said that Stony Indians once crossed the mountains to gather or trade for this herb. Crow Indians dried and crushed the plants to line baby cradles, while other Indians even stuffed their pillows with it.

Alex Left-hand, a Kootenai, said that the small, yellowish-green flower heads were occasionally eaten and that children liked to make necklaces from the dried heads.

Description, Habitat, and Range

Pineapple weed is a much-branched, leafy annual which seldom exceeds one-half foot in height. The pinnate leaves are dissected into linear-shaped segments. The flowers are scarcely one-half inch wide, light green in color, and lack ray flowers.

It is a native of the Northwest and occupies waste places, yards, and dry prairies. In recent times it has spread to other parts of North America.

Glacier Lily

Erythronium grandiflorum Pursh

The bulbs of glacier lily served only as an occasional food source to the Indian tribes of our region. The difficulty of digging these deep-seated bulbs no doubt contributed to the infrequent collecting of them. One can eat the bulbs raw or boil them; the leaves may be eaten as a salad plant or as a potherb, although the Indians made no apparent use of them. The bulbs and leaves occasionally impart a burning sensation, however, and some have even found them to be emetic (causing vomiting) if taken in quantity.

Though glacier lilies can be locally abundant, they should not be indiscriminately gathered; any wildflower as showy as this should be left to beautify the woodland and meadow landscapes. It is comforting, however, just to know that it is there in case of an emergency and that it serves as a natural food source for bears, ground squirrels, and other wildland inhabitants.

Description, Habitat, and Range

Glacier lilies have brilliant yellow, nodding flowers, each with distinctively recurved petals rising from a long, six- to twelve-inch naked stem. Each plant has two oblong-shaped, shiny basal leaves which measure from four to eight inches in length. The deep-seated bulbs are crisp and white inside.

This wildflower inhabits sagebrush slopes, montane forests, and moist subalpine and alpine meadows. Its range extends from British Columbia and Montana south to Colorado and California.

Lovage

Ligusticum canbyi Coult. & Rose

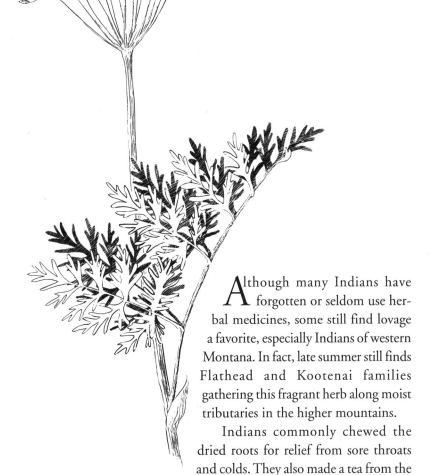

Although many Indians have forgotten or seldom use herbal medicines, some still find lovage a favorite, especially Indians of western Montana. In fact, late summer still finds Flathead and Kootenai families gathering this fragrant herb along moist tributaries in the higher mountains.

Indians commonly chewed the dried roots for relief from sore throats and colds. They also made a tea from the roots if someone didn't want to chew on the strongly aromatic roots. They chewed it for relief from toothache, headache, stomachache, fever, and heart problems.

Sophie Adams, a Flathead from Camas Prairie, recommended a special hair rinse made from lovage roots and leaves of buckbrush (*Ceanothus*

velutinus). For seizures, she explained its use: "We get this root. We have to chew on it and just rub it on a person's body. We also rolled cigarettes with this root in it and let the person smoke it. That calms the seizure down."

Although lovage is not found in eastern Montana, its curative properties are known to some of the Indians who reside there, such as the Cree and Crow tribes. Crees used the tea as a heart medicine and eagerly traded with western Montana Indians to obtain it. The Crows obtained theirs from Nez Percés, longtime historical allies. The Crows similarly chewed the root for coughs and colds, their singers using it so that their voices did not play out too soon. They added shavings of the root to boiling water for a steam inhalant for sinus infection and congestion and drank the tea from it for colds and coughs. They placed one or two drops of the tea into the ear for earache, and applied a poultice from the shavings on an abscessed ear. Shavings added to tobacco and kinnikinnick provided a good smoking mixture or, sprinkled on live coals, produced a pleasing incense.

In case you collect this root, be careful not to wash the roots until you are safely out of the mountains or unless you brought your raincoat. Flatheads warned that doing so insures a rainstorm.

Description, Habitat, and Range

Lovage is a delicate, tall perennial herb measuring one and a half to four feet in height. It has long, dissected leaves whose ultimate segments are triangular. It is a member of the parsley family and, like other members, its flowers are arranged in umbrella-like heads.

It is found in the higher mountains in wet soil. It ranges west of the Continental Divide in Montana, through Idaho, to north-central Washington and to the Blue Mountains in Oregon.

Yellowbells

Fritillaria pudica (Pursh) Spreng.

The bulblike underground corms of yellowbells formed a minor portion of the native people's vegetable diet in Montana. Flathead women normally gathered them in early May, about the time the bitterroot was ready for digging. They washed, boiled, and often mixed these corms with bitterroot. Apparently the Indians never dried and stored them for future use.

The fruiting pods are edible, although this fact seems to have escaped the indigenous Indian tribes. Boiled in water and then prepared with butter, salt, and pepper, they make a tasty treat.

Wild animals such as bears, gophers, and ground squirrels avidly dig for these corms. No doubt deer and other ungulates graze their leafy tops.

Description, Habitat, and Range

This plant is not easily mistaken for others. Its single golden-yellow, bell-shaped flower hangs downward or sidewise from a bent stalk. It begins blooming in March, and the flower soon fades to red or purple. The slender, blunt-tipped leaves, often two or three in number, measure from two to four inches in length. Yellowbells rise three to eight inches from starchy corms measuring almost an inch in diameter.

It can be found in grasslands, sagebrush deserts, and conifer forests. It ranges in western North America from British Columbia and Montana south to California and New Mexico.

Biscuitroot

Lomatium cous (Wats.) Coult. & Rose and related species

This is the cousroot of the Nez Percé Indians and the *racine blane* of French-speaking Canadians. Others called it bread- or biscuitroot, after the stale biscuits made from its roots. Nez Percé Indians regarded biscuitroot as an important root crop, second only to camas. Other Indians also esteemed the starchy tubers. Flatheads, for example, traded with the Nez Percés of Idaho for their larger and more abundant biscuitroot.

Indians dug the root in spring just after the plant had bloomed, normally in early May. They peeled them and ate them raw or boiled them. They sun dried some whole for future use, pulverizing the rest with a mortar to make a gruel for immediate consumption or to form into bricks or cakes. Some of the cakes were large—one person described them as "one foot wide, three feet long, and from a quarter to half an inch thick."

To make cakes, Indians moistened the flour and formed it into bricks which they suspended on a swinging framework of flat sticks—the bricks bore the imprint of these sticks—and partially baked them over a fire. They pierced the cakes with one or more holes through which they strung a thong; thus they could hang the food from their saddles. Nez Percé Indians made different types of cakes. One was large, about a foot long, and capable of being kept for about a year. Another, called finger cakes, they formed by pressing a small piece of dough with the fingers. They ate these without further preparation, or broke them up in water and made a soup from them. If properly dried, biscuitroot kept for one or two years.

Indians use other species of biscuitroot, notably the roots of *Lomatium triternatum* which they ate raw, roasted, or baked. Nez Percé Indians baked the roots of *Lomatium dissectum* for one or two days in a fire pit, as camas was prepared, while the Flatheads ate raw, or dried for future consumption, the roots of *Lomatium macrocarpum*.

Other tribes employed various species of biscuitroot for medicinal purposes. Cheyenne Indians made a medicine from *Lomatium orientale* to relieve pain in the bowels and for diarrhea; they pounded the roots and leaves to make a tea or ate them dry. The Cheyennes pulverized the root of another species to make an infusion for swelling; it gave a cooling sensation and a greasy feeling to the skin. Nez Percé Indians made a medicine from *Lomatium dissectum*, removing the oil from the roots and rubbing it on sores, including sore eyes. They mixed it with tobacco and smoked it in a pipe to cure sinus trouble. To cure tuberculosis or increase

appetite, these Indians drank a tea made from the cut up roots.

Crow Indians called *Lomatium macrocarpum* "bear root." They used it for medicinal purposes and prepared the root by roasting it in a bed of coals and scraping off the outer, burnt crust. For sore throats, they chewed on the root and swallowed the juice. For colds, they drank a tea made from the root shavings mixed with animal fat. To treat swellings, they prepared a poultice from the boiled root shavings and kept the shavings moist with the same infusion used for colds. For ceremonial incense or to purify and deodorize the air, they sprinkled root shavings on live coals. For a salve, they boiled the pulverized root shavings with melted tallow and a small amount of water until the water boiled off. Blackfeet Indians made a tea from the roots which they drank for a weakened condition. For horse distemper, they made the animals inhale the smoke of the burning root or gave them a decoction made from it.

Description, Habitat, and Range

Biscuitroots are perennial plants with divided leaves and flowers arranged in umbels. *Lomatium triternatum* has leaves which are dissected into long and narrow divisions with smooth margins, these often appearing as narrow leaves. It has a slender taproot. The other species mentioned have leaves dissected into numerous, small and short divisions. *Lomatium cous* is a small plant, with a short and strongly thickened root and leafless flowering stems. *Lomatium dissectum* is a larger plant, often twelve to thirty inches tall and has leafy flowering stems. *Lomatium macrocarpum* and *Lomatium orientale* both have leafy flower stems but differ in other ways. *Lomatium macrocarpum* has white, yellow, or purple flowers and bracts equal to or exceeding the flowers in length, and a swollen taproot. *Lomatium orientale* has white flowers, bracts equal to or shorter than the flowers in length and a slender taproot.

The different species of biscuitroot grow on dry ground in the more arid portions of the West.

Other Common Names

Breadroot. Cousroot.

Rush Skeletonweed

Lygodesmia juncea (Pursh) D. Don

Modern women seldom worry about having insufficient milk; there always seems to be enough cow's milk to feed their growing infants. But long ago, before cow's milk was available, Cheyenne mothers drank a medicine to increase their milk flow. They made a tea from the dried stems of skeletonweed, or, as they called it, "milkweed." They attributed other qualities to the bluish-colored tea they made from the plant: it brought a feeling of contentment to the mother and reputedly possessed an "inner power" which gave strength to the infant. Cheyenne women drank the tea alone or in combination with baneberry, *Actaea rubra*. In addition, Sioux Indian mothers, who also drank this medicinal brew to increase milkflow, used the infusion to treat sore eyes and collected the hardened juice, which exuded from broken stems, to chew for its flavor.

Description, Habitat, and Range

Rush skeletonweed is a rushlike plant with tough, rigid, and nearly leafless green stems measuring from four to twenty inches tall. The stems exude a milky juice. Its upper leaves are very small and scalelike, while the lower ones are longer, from one to one and a half inches. The solitary flower heads are pink and located at the ends of the branches.

The plant inhabits sandy areas of the Great Plains.

Purple Coneflower

Echinacea angustifolia DC.

Thirsty and exhausted from several days without food, water, and sleep, Cheyenne Sun Dancers relieved their parched mouths by chewing the roots of "black medicine." No doubt countless other thirsty people of the dry and wind-swept plains employed this natural salivant.

Among some Plains Indians, few found a plant as versatile as the purple coneflower for its curative properties. Cheyenne, Crow, and Sioux chewed the root for relief from toothache. Cheyennes powdered the roots and leaves to make a tea drunk for sore mouth, gums, and throat; other Cheyennes drank the decoction for rheumatism, arthritis, mumps, and measles, and additionally applied it as a salve to the affected part of the body. Crow Indians chewed the root for colds and drank its tea for colic. For burns, Cheyenne and Sioux Indians applied a decoction of the root to bring cooling relief. Sometimes Indians mixed several ingredients to make a particular medicine. Cheyennes, for instance, mixed the roots of purple coneflower, the spores (or "powder") of puffball mushrooms, and skunk oil; they applied this to boils after a medicine person sucked and lanced them. Sioux used this plant in the smoke treatment for distemper in horses and headache in persons.

Sioux Indians and early white traders probably knew coneflower best as an antidote for rattlesnake and other venomous bites, stings, and poisonous conditions. Sioux "jugglers" bathed their hands and arms in the juice to protect themselves while handling hot meat with their bare hands. In view of all these reputed properties, the medical profession might investigate purple coneflower's merits.

Description, Habitat, and Range

Purple coneflower rises from one to three and a half feet in height from a taproot. The rather hairy leaves are mostly basal and are lanceolate to linear shaped. The flower heads are solitary, and the individual ray flowers are rose to purple in color.

The plant inhabits dry, open prairie and the plains regions of the central and eastern United States.

Sweetgrass
Hierochloe odorata (L.) Beauv.

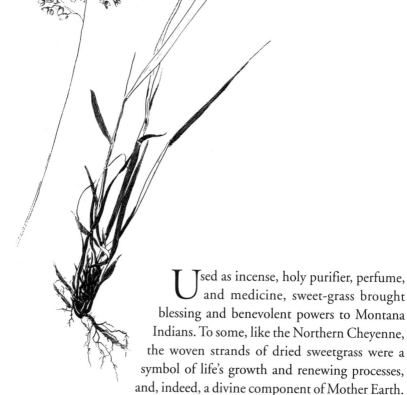

Used as incense, holy purifier, perfume, and medicine, sweet-grass brought blessing and benevolent powers to Montana Indians. To some, like the Northern Cheyenne, the woven strands of dried sweetgrass were a symbol of life's growth and renewing processes, and, indeed, a divine component of Mother Earth. Jim Spear, a Cheyenne priest, told the following story regarding sweetgrass in the Cheyenne creation story:

> This creator, whom we call Maheo in our language, held out his left hand, and his power being such that he got five strings of sinew. He laid them down. And he next put down sweetgrass, this being laid down the same way as he had sinew. Then he produced buffalo tallow. Then he produced red paint. He put

that on there. Then he started to put these things together. He rolled that into a ball. Then he blew on it four times. The fourth time he let it go. And it grew and grew. This is the earth. There was water on it, grass, trees, everything that grows. Maheo had the power to do that.

Nearly all Montana Indians burned sweetgrass as incense for its spiritually purifying and protective properties. It was especially beneficent to Cheyenne Indians. They burned it to insure protection from lightning and thunder. During healing ceremonies, Cheyenne doctors passed the rattle through sweetgrass smoke to purify it. Cheyenne men purified their sacred shields with its vapors before going to battle, or to prevent contamination from menstruating women. A Cheyenne woman might face her son-in-law if she gave him an ornamented robe, and incensed it—and him—with this holy smoke. Contrary warriors made sure their sacred lances passed through the purifying smoke of sweetgrass before another brave used it in warfare.

Cheyennes periodically renewed their Sacred Arrows with sweetgrass. These arrows were the spiritual gift of the Cheyenne cultural hero and prophet, Sweet Medicine, who reportedly lived with the Cheyenne for 445 years. Sweet Medicine obtained these arrows, or "Mahuts" as the Cheyenne call them, from Bear Butte, a sacred mountain near Sturgis, South Dakota. When Sweet Medicine carried these arrows out of the lodge within Bear Butte, he burned sweetgrass to purify the outside world for their entry into the physical universe. Consequently, whenever the arrows were exposed, Cheyenne Sacred Arrow priests burned sweetgrass to purify the air for the exposure of the holy arrows. Cheyenne Indians conducted the Sacred Arrow Ceremony to insure the health of the people and an abundance of grass, berries, buffalo, and other animals. The burning of sweetgrass constituted the most important ritual in the Renewal Lodge, during which priests and warriors renewed their sacred bundles, weapons, clothing, and contrary lances. Sweetgrass was burned 445 times, duplicating the number of years which Sweet Medicine lived. In Jim Spear's words, "We retrace that. We renew the arrows. We renew the life of the Cheyenne people through the use of this sweetgrass."

Blackfeet, Sioux, and Cheyenne made use of sweetgrass incense in the Sun Dance to purify the dancers. Sioux and Blackfeet ceremonially smoked sweetgrass leaves with tobacco, possibly to summon the benevolent

powers which sweetgrass possesses. Sioux indoctrinated to Christianity carried sweetgrass with them to church on Palm Sunday and used it to tie palms to their homes after the ceremonies, an old-time association of sweetgrass with sacred ceremonies. Crow Indians burned sweetgrass for the benefit of the bereaved. Many Montana Indians burned it inside their homes and lodges for its general purifying effects, and in one Cheyenne's words, "so that evil will not come about."

And in less spiritual ways, Indians perfumed themselves and their belongings with the fragrance of this significant plant. Blackfeet and Flathead women decorated their hair with braids of sweetgrass, while Blackfeet and Gros Ventre Indians soaked its leaves in water to make a hairwash. Many placed it in suitcases with clothes to make them smell better, and as one Flathead said, "to keep the bugs away." Or better yet, they incensed their clothes with the smoke. Most, if not all, perfumed themselves with sweetgrass, normally by placing it in pouches or in articles of clothing. Gros Ventre Indians mixed sweetgrass with castor oil from beaver for an additional aromatic perfume.

Some used it for ordinary medicines. Blackfeet suffering from colds inhaled smoke from its burning leaves for relief. Flatheads made a tea which reputedly cured colds and fevers, and alleviated "sharp pains inside," or they mixed it with seeds of meadow rue, *Thalictrum occidentale*, to make another tea to clear congested nasal passages.

Today, sweetgrass has become scarce and is hard to find. Part of the reason, laments Jim Spear, is that we are losing our old ways.

Description, Habitat, and Range

Sweetgrass is a fragrant grass with stems up to two feet tall, these being characteristically reddish at the base. It inhabits meadows, bogs, and moist places from Labrador west to Alaska, south to New Jersey and Iowa, and to Oregon, New Mexico, and Arizona. It also grows in the Old World.

Spring Beauty
Claytonia lanceolata Pursh

Flathead and Kootenai Indians called spring beauties Indian potatoes, because the roots reminded them of the larger tubers of the domestic potato introduced by white men. After a long and hard winter, when they were sustained only by meat and various dried roots, tubers, bulbs, and berries, Indians welcomed the sight of spring beauty, the first crop which they dug in early spring. They ate some of these crisp, tuberlike corms fresh; others they washed and boiled, just like potatoes. Apparently Indians did not dry and store them for future use, since they were too small to gather in sufficient quantity. In the mountainous high country, hikers and backpackers prize these savory rootstocks. So, too, do various wild animals: marmots, ground squirrels, and grizzly bears.

Description, Habitat, and Range

Spring beauty is a delicate perennial herb which stands four to eight inches in height. It has five pinkish-white petals, which are subtended by two green sepals. The lance-shaped leaves occur in pairs, each measuring from two to four inches in length. The tuberlike corms are small, but sometimes measure up to one and a half inches in diameter.

The plant is found normally in moist soil, from lower foothills and open mountain slopes to alpine meadows, frequently below snowbanks. It ranges throughout the Rocky Mountain region and west to the Pacific states.

Other Common Names

Indian potato.

Sunflower

Helianthus annuus L.

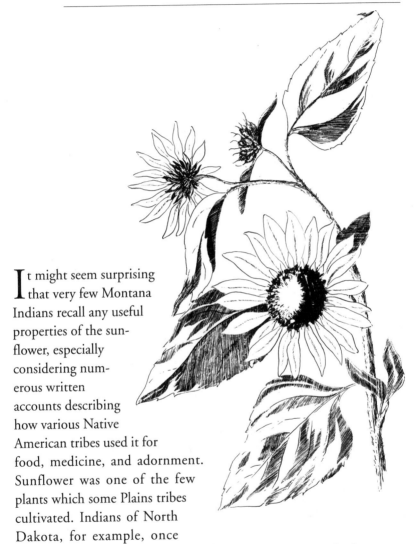

It might seem surprising that very few Montana Indians recall any useful properties of the sunflower, especially considering numerous written accounts describing how various Native American tribes used it for food, medicine, and adornment. Sunflower was one of the few plants which some Plains tribes cultivated. Indians of North Dakota, for example, once grew several varieties of sunflower, together with maize and other crops, along the Missouri River. Some ate the sunflower raw, but generally they dried the seeds by heating them in a pan or pot over a fire. Then they powdered the seeds, from which they made a gruel by boiling or cakes by adding grease. Warring Indians often took sunflower cakes with them on

their marches, the cakes sustaining them against fatigue better than any other food. For adornment, Indians anointed their hair and bodies with oil extracted from the seeds, and the Sioux ascribed various medicinal qualities to sunflowers. But Indian agriculture died out long ago, and apparently with it died any knowledge of the sunflower's past uses, despite the fact that the less robust wild and weedy counterparts still exist.

Strangely, sunflower as a cultivated plant is known best far from where it originated in temperate North America. Today it grows mostly as an introduced plant in Russia, Rumania, Argentina, and Bulgaria, although it once again is enjoying importance in the United States as a crop plant.

Sunflower came to the attention of Europeans at least by 1568, when the herbalist Dodonaeus described it. Since then, herbalists and early pharmacists have prescribed sunflower for various physical complaints. The seeds, in the form of a decoction, have been described as a diuretic and expectorant, and have accordingly been employed for bronchial and pulmonary afflictions, coughs, colds, and whooping cough. Some have claimed that the mere presence of it around a dwelling protects one from malarial disease, but a less fanciful prescription recommends drinking an infusion of the stems for malaria.

Description, Habitat, and Range

Sunflowers are annual plants reaching one to eight feet in height. The leaves are rough-hairy, two to ten inches long and about half as broad. There are two kinds of flowers in each flower head: reddish-purple to brownish disk flowers in the center and yellow ray flowers on the margins.

Sunflowers often grow on arid ground of open plains and valleys from the Mississippi River westward, but they are found cultivated and established elsewhere.

Western Yew
Taxus brevifolia Nutt.

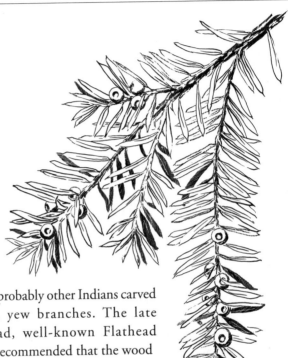

Flathead and probably other Indians carved bows from yew branches. The late Pete Beaverhead, well-known Flathead medicine man, recommended that the wood first be seasoned and that the finished product be varnished with boiled animal sinew or muscle before use.

The foliage, bark, and seeds of the various yews contain a toxic alkaloid, taxine. It is extremely poisonous if ingested and often fatal.

Description, Habitat, and Range

Western yew is a small tree, ten to forty feet tall, with drooping branches and dark green foliage. The needlelike leaves are generally one-half to three-quarters of an inch long, sharply pointed, two ranked, and form flat sprays.

It inhabits cool canyons from western Montana northwest to coastal southern Alaska and south to California.

Prickly Pear Cactus
Opuntia polyacantha Haw.

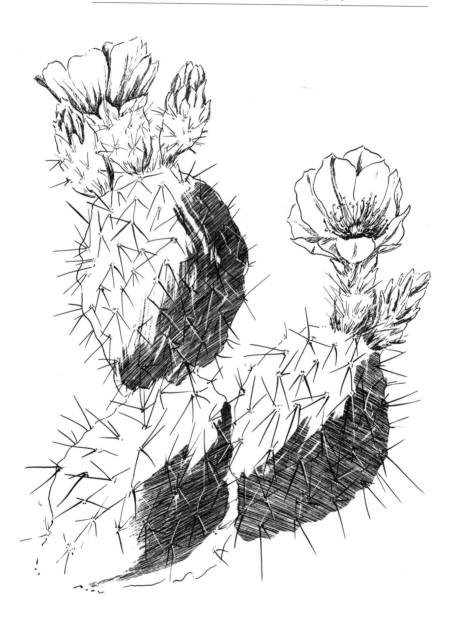

It might have been a hungry Indian who discovered the edibility of cactus. But despite the painfully sharp spines, the red fruit (or prickly pear) furnished many Indians and settlers with food. Indians often ate the fruits raw, and what they could not immediately consume they dried and stored for winter. Cheyenne women prepared the fruits by sweeping piles of them with sagebrush branches to remove the spines. What spines still clung they picked off with fingers protected by deerskin tips. Next they split the fruit, discarded the seeds, and placed the pulp in the sun to dry. They ate it mixed with stew or in soups which its gelatinous content thickened. Some people ate the stems, too, but it is not clear whether Indians regularly used them. M. R. Gilmore stated that the Sioux usually ate them only during times of scarcity. C. A. Geyer, an early botanist, said that they afforded "quite a reasonable refreshment, in taste resembling raw cucumbers." White settlers prepared the stems by boiling, which facilitated removing the skin and prickles, then frying the pulpy interior. In times of scarcity some singed the spines off and fed the stems to livestock.

Settlers along the Missouri River used prickly pear cactus to clear muddy water. To do this they split the stems and placed them in a receptacle of water which was cleaned by the extruded mucilage. In order to fix colors on hides, Sioux and Crow Indians rubbed a freshly peeled stem over the paint. Sioux also used the peeled, mucilaginous stems as a dressing for wounds. Some Flatheads used prickly pear stems for backache; they burned off the spines, smashed the stems up, and then placed them on the affected area. They also boiled these stems to make a tea drunk for diarrhea.

Description, Habitat, and Range

Prickly pear cactus has jointed, usually flattened, and spiny stems. Its minute, fleshy leaves are borne in the spine clusters and soon fall away. The showy, waxy flowers are pink in color.

Prickly pear grows in some of the hottest, driest localities from sea level to six thousand feet, from Alberta and British Columbia south to Arizona and Texas.

Alumroot

Heuchera cylindrica Dougl. ex Hook.—*Heuchera parvifolia* Nutt. ex T. & G.

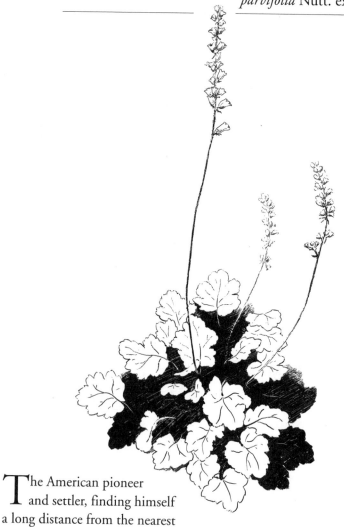

The American pioneer and settler, finding himself a long distance from the nearest doctor, often had little choice but to use the Indians' *materia medica* for relief from sickness and pain. Some of the Native Americans' remedies the pioneer came to regard as merely superstitious and, to him, of little therapeutic value. Others he learned were highly efficacious, and he incorporated them into his own pharmacopoeia, often failing to give

proper credit to the discoverer. Alumroot is one such herb, originally discovered by the Indians and passed on to the American's store of medicines.

For Flathead Indians, a remedy made from this plant cured diarrhea and stomach cramps with which they were often plagued during the summer months from eating too many vegetable foods. Pete Beaverhead, a Flathead medicine man, said that drinking half a pint of tea made from the roots brought relief in "no time." The root can be chewed for direct relief. Of all the plants known for stomachache and diarrhea, said Pete Beaverhead, this was the best one. Non-Indians eventually learned of its healing qualities, too: pharmaceutical reference books and journals mention the astringent and counter-dysentery properties of alumroot, and early settlers, suffering from diarrhea caused by drinking alkaline water, came to regard alumroot as a useful medicine.

Kootenai Indians used a decoction made by boiling the roots for "aching bones," apparently using it to wash the afflicted areas. Adeline Mathias and Alex Left-hand, a Kootenai couple from Hot Springs, added that the tea could also be drunk for tuberculosis.

The early American physician, Dr. Barton, mentioned other aboriginal uses of alumroot which were passed on to the newly arrived pioneer. These included remedies for healing wounds, sores, obstinate ulcers, and even curing cancer.

Description, Habitat, and Range

Alumroot is a perennial herb with stout, scaly rootstocks. The lobed to coarsely toothed leaves are round to heart shaped, about one to two inches long and attached by a long stalk to the base of the plant. The tiny, cream-colored flowers are attached individually to a stalk one-half to one and one-half feet above the plant's base.

Alumroot is found principally in sunny, rocky habitats: cliffs, rock piles, talus slopes, and gravelly soils. It is widely distributed in the Rocky Mountains from British Columbia and Alberta south through Montana and northern Nevada.

Gumweed

Grindelia squarrosa (Pursh) Dunal

Man discovered some re-markable healing qual-ities in gumweed. The American medical profession learned of it early from North American Indians. In 1863, Dr. C. A. Canfield of Monterey, Cali-fornia, called attention to the native Indian use of the plant as a remedy for poison ivy. Not long afterward, gumweed became a standard medicine, not only for treatment of poison ivy but for dealing with a host of other ailments. It was officially recognized in the *United States Pharmacopoeia* from 1882 to 1926, and in the *National Formulary* from 1926 to 1960.

In common with other medicinal plants, gumweed contains a rich storehouse of chemicals, including amorphous resins (21 percent), tannic acid, volatile oils, and the alkaloid grindeline. The fluid extract "elixir of Grindelia" is obtained from the leaves and flowering tops, which are collected when the plant is in full bloom. The odor is balsamic and the taste slightly bitter, resinous, and sharply aromatic. Elixir of Grindelia is a stimulating expectorant; it has the property of expulsion or loosening of the mucous of nasal and

bronchial passages. In view of this physiological action, the early medicinal uses of gumweed seem credible. Flathead, Crow, and other Indians and early white Americans variously drank "Herba Grindelae" for coughs (including whooping cough), pneumonia, bronchitis, asthma, and colds.

We can add gumweed to the list of plants used to treat various kidney and bladder disorders. Sioux Indians drank gumweed tea for kidney problems. Europeans and Americans used the extract to treat the bladder, especially cystitis (inflammation of the bladder). However, the drug causes some irritation to these organs.

Indian and non-Indian herbalists used gumweed for a multitude of other medical problems. The Northern Cheyenne boiled the flowering tops and used the decoction to wash sores and other skin lesions. They also found this herb useful for snow blindness: the sticky flower heads were rubbed around the eyes for relief. Gros Ventre and other Indians used a decoction of this herb to treat syphilis. Flatheads rubbed horses' hooves with the flower heads to toughen and protect them against injury; they also drank the tea for tuberculosis. Sioux Indians drank it for colic; Blackfeet drank it for "liver"; and the Crow sniffed it up their noses for catarrh. Pharmaceutical books further describe "Herba Grindalae" as sedative, antispasmodic, tonic, and useful for fevers and burns. It is known to have a depressant action upon the heart but has never been employed for that purpose.

If you are not suffering from any of these complaints, then perhaps you can try a hot gumweed tea. As Pete Beaverhead, a Flathead, said, the oldtimers drank it just to "pep them up."

Description, Habitat, and Range

Gumweed is a much-branched, almost shrublike herb which stands from one-half to two and a half feet tall. Its numerous yellow flower heads are approximately one-half inch across when fully expanded and are subtended by a series of narrow, recurved, gummy bracts.

This weedy member of the sunflower family can be found in open, dry areas of valleys, plains, and foothills. There are some fifty species of gumweed; all are native to western North America and to South America. This particular species is found in the Rocky Mountain region, especially in Idaho and Montana.

Showy Milkweed

Asclepias speciosa Torrey

Plains Indians of eastern Montana ate milkweed's young, unopened flower buds. Cheyennes, for instance, boiled these immature flowers in water with soup or meat, and by adding flour, they made a gravy. Some authorities have claimed that the flowers have a tenderizing effect on meat and that they also have a high sugar content which boils down to make a thick syrup. Cheyennes also peeled the immature fruits to eat the inner layer. Crow Indians similarly prepared milkweed flowers and fruits.

The reader is advised not to eat milkweed raw, however, for modern authorities attribute livestock poisoning to it. Wild food enthusiasts cook the young, four- to eight-inch-high shoots like asparagus. By breaking the leaves down the stem, Cheyennes caused the milky juice to exude, and after it hardened, they used it as a chewing gum. The Crows once used the milky juice for temporarily branding livestock, the place of its application remaining dark for several months.

Cheyennes also made an eye medicine from milkweed. To prepare it, they boiled the top part of the plant and strained the decoction, applying it to the eyes with a clean cloth. Elsie Wick suggested that it must be for general blindness or snow blindness. Flathead Indians called milkweed "stomachache medicine." They drank a tea made by boiling the dried, pulverized roots, although occasionally they chewed the fresh roots.

Description, Habitat, and Range

Milkweed is a stout, hairy herb which stands two to three feet tall. The pale green, oppositely attached leaves are clustered in terminal umbels. Plants are rhizomatous, with thickened, fleshy roots. It is found in moist meadows and waste places, along fences and streambanks, in loamy to sandy soil. It occurs mostly in central and western portions of North America.

Yellow Pondlily
Nuphar variegatum Engelm. ex Clint.

Indians occasionally encountered some difficulty in procuring their plant foods and medicines. They found collecting the yellow pondlily, for instance, no easy task, considering that the fleshy rootstocks grow submerged under four or five feet of water. Some opportunistic Indians raided muskrat houses, which held caches of them, but most ambitiously dove underneath the water to bring up the long chunks of rootstocks. Nevertheless, the pondlily in early times constituted a welcome addition to the first Americans' sustenance and pharmacopoeia.

To eat the scaly rootstock of this plant, Indians first removed the rind to expose the glutinous, spongy, but sweet contents. Some ate them raw but most boiled them, often with meat. Thin slices could also be dried, ground, or pulverized into meal or gruel, and used, for example, to thicken soups.

The seed-bearing pods float on the water's surface. These, too, some people have added to their diet. The pods are dried and pounded to remove the seeds. For consumption, the seeds are parched over a slow fire in a frying pan. This causes them to pop, but much less enthusiastically than does popcorn. The parched seeds are separated from the hard shells by winnowing; they can be ground into a meal and variously used for mush or gruel.

Most Montana Indians have forgotten the edible properties of pondlily. A few "old timers," however, still recall its medicinal value. At one time they used the rootstocks to bring about a cure to an especially bothersome malady, venereal disease. Mitch Small Salmon and Pete Beaverhead, two Flathead medicine men, recommended using it as follows: the rootstock is boiled and the resulting tea drunk to open the urinary tract; meanwhile, the crushed roots are placed on the "affected" areas to bring relief. Flathead and Kootenai also employed the rootstocks for sores; the baked rootstocks were sliced or mashed and applied as a poultice. The Sioux similarly applied the powdered rootstocks as a styptic to wounds. Bob and Sophie Adams, Flatheads from Camas Prairie, suggested adding the decoction, made by boiling the rootstocks, to bath water to treat rheumatism.

The Indian's horse was by no means left to fend for itself, especially when plagued with sickness or injury. The Flathead medicine man, Pete Beaverhead, employed pondlily rootstocks for bad bruises and cuts. These rootstocks were either boiled and mashed to form a poultice, or they were baked in a firepit before being applied.

Description, Habitat, and Range

Pondlilies rise from thick rootstocks anchored in the soil of ponds and lakes. The floating leaves measure from four to sixteen inches long. The large, waxy flowers float on the surface, too; they are yellow, but sometimes reddish-tinged, and measure from three to five inches long. The fruit is podlike and leathery, often the size of a hen's egg, and contains large seeds.

The plant can be found in quiet ponds and along shallow lake shores from valleys to mid-elevations in the northern United States and southern Canada.

Pipsissewa

Chimaphila umbellata (L.) Bart.

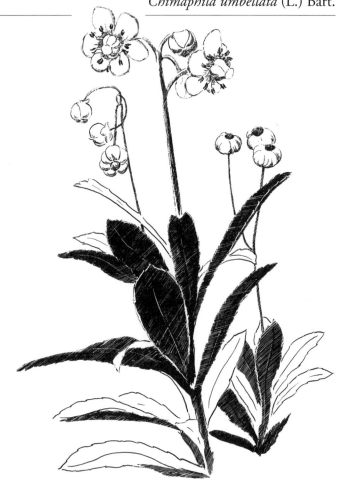

M any North American tribes used pipsissewa as a medicinal plant. From their hands it passed to early European settlers, and it was for a long time a popular folk remedy before final adoption by the medical profession.

Flathead and Kootenai Indians primarily used it as an eye medicine. According to Pete Beaverhead, a Flathead from Ronan, the solution made from this plant was put on eyes, alleviating smarting from heat, smoke, or perspiration. Joe and Mary Antiste, a Kootenai couple from Big Arm,

mentioned that this medicine dries the eyes. Various scientific journals describing medicinal plants mention the astringent properties of pipsissewa, properties which include that of diminishing secretions, as in the eyes.

In non-Indian medicine, pipsissewa is best known for its treatment of kidney disorders. Scientific reports indicate that it increases urinary flow and has been beneficially useful as a disinfectant for kidneys. The Kootenai Indians knew of this medicinal property of pipsissewa, too, as Suzette Phillips of Big Arm mentioned. She said that the tea made from this plant can be drunk for kidney trouble.

Others knew it as an effective remedy for fever. Some Indians drank the tea made from it for this purpose. Early Americans came to recognize its value as a diaphoretic and employed it for fever trouble.

Pipsissewa contains chimaphilin, arbutin, gum, resin, starch, and pectic acid. In addition to the properties and uses mentioned above, herbalists employed it for its tonic, alterative, vesicant, and rubefacient properties. They also found it helpful for gonorrhea and scrofulous disorders, applying a solution of it externally.

Finally, in case one needs a smoke, he can try the leaves of this woodland shrub, as did the Flatheads and others. Pete Beaverhead said the tribe would hang the leaves in the sweathouse to dry before smoking them.

Description, Habitat, and Range

Pipsissewa is a small evergreen shrub which seldom exceeds one foot in height. The shiny green leaves are lance shaped, leathery, toothed on the margins, and average about two inches in length. The plant has waxy pink flowers arranged in a cluster above the leaves, and it arises from long, woody, underground stems.

It is a common shrub and occurs in relatively moist coniferous woods. It ranges throughout much of North America, Europe, and Asia, where it frequents the northern boreal forest.

Other Common Names

Prince's pine. Wintergreen. Waxflower.

Wild Licorice

Glycyrrhiza lepidota Pursh

Once some Cheyenne girls saw a bearded and beautifully long-haired white man walking along a trail. They called to the man to come to them. "No," he replied, "I'm in a hurry; I've got to go somewhere." The girls insisted that he come to them for just a few minutes so they could fix his hair. At last he agreed and sat down while the girls began working on his hair. Soon the white man fell asleep. Finding this an opportune moment for mischief, the girls entangled his beautiful hair in the burrs from wild licorice and then left. Awakening, the white man discovered his tangled hair, and, not being able to remove the burrs, had no choice but to cut off all his hair.

Other Cheyennes made more beneficial use of wild licorice: they boiled the roots or leaves to make a tea for stomachache and diarrhea, chewed upon the roots to cool themselves in the sweatlodge and Sun Dance ceremonies, and cut the young shoots in the springtime and ate them raw.

Some Indians chewed the root and swallowed the liquid in the belief that it would strengthen the throat for singing; they also boiled the root and drank the tea as a tonic. Sioux Indians chewed licorice root leaves and applied this as a poultice to sore backs of horses. One Sioux suffering from a toothache chewed the root and held it in his mouth for relief; he noted that at first the taste was strong but after a while became sweet. Sioux also steeped the leaves and applied them to aching ears and made a tea from the roots for children's fevers.

Lewis and Clark noted that the root was prepared as food by roasting in it embers, then pounding it with a stick in order to separate the strong ligament from the center of the root. They then threw away the ligament and chewed up and swallowed the rest. Lewis and Clark observed that the taste resembled sweet potato.

The closely related European species, *Glycyrrhiza glabra*, held an important position in early medicine. Doctors prescribed the decoction made from the root for relieving internal inflammation, attributing its medicinal value to its ability to protectively coat membranes. They found this medicine useful for infections of the mucous membranes of the nose and air passages, bowels, and urinary passages, and as a mild laxative. Licorice also became useful as a flavoring agent to mask unpleasant-tasting drugs and it flavored confections, root beer, and chewing tobacco.

Description, Habitat, and Range

Wild licorice is a one- to three-foot tall perennial herb. It arises from deep, creeping stems. The flowers are white and occur in dense clusters. The leaves are comprised of from ten to twenty leaflets, each being about one inch long. The burrlike, brown pods are about one-half inch long.

It is especially abundant along river bottoms, in moist draws and waste places, and along roadsides. It occurs abundantly in eastern Montana but also ranges from southern California northeast to Ontario and occasionally in Idaho and Washington.

Snowberry

Symphoricarpos albus (L.) Blake

Consider the snowberry's useful virtues: Flathead Indians applied the crushed leaves, fruits, and bark as a poultice for sores, cuts, chapped, or injured skin or used it to cover scabs and burns to promote rapid healing with no scarring. They also made an eyewash from the bark of snowberry and wild rose. But for immediate application, say when someone poked his eye when hunting, Flathead Indians chewed the fruit and then placed the resulting juice in the eye. At first the eye muscles tightened up, but they soon felt better. Sioux Indians also made an infusion for sore eyes.

Nez Percé Indians boiled snowberry twigs to make a brown tea drunk to cure fevers. The patient took this medicine often if the fever was bad. While adults could drink as much as they liked, children could take only small doses. Nez Percé Indians also looped snowberry branches around cradleboards to keep babies safe from ghosts. Kootenai women cut up the branches to make a tea drunk for general female troubles, such as menstrual disorders.

The Kootenai tell a story of how Coyote attempted to make arrows from snowberry wood. The tale is humorous, considering that the twigs are bent and twisted and therefore would make exceedingly poor arrows. Blackfeet made fires from the green twigs to blacken the surface of newly made pipes; they then greased the pipes with animal fat and polished them with a piece of skin. Crow Indians made a solution by boiling crushed snowberry roots and gave it to horses failing to void. Sioux gave a similar solution made from the boiled berries as a diuretic.

Description, Habitat, and Range

Snowberry is a shrub which stands about two to five feet tall. It is named for its white berries, which measure a quarter to a half inch in diameter. The leaves are one-half to one and a half inches long, oval shaped, dull green colored, and rather thick. This is a widespread species on hillsides and mid-montane slopes.

Rocky Mountain Juniper
Juniperus scopulorum Sarg.

Plains Indians ascribed a mystic sacredness to juniper. They venerated its evergreen quality, which conspicuously sets it apart from the seemingly stark prairie environment. Charles Sitting Man, a Cheyenne, said that the Great Spirit has much respect for juniper because it seems to never grow old and remains green the year round. It therefore represented youthfulness, and they accordingly placed it centrally in many of their holy rites and purification ceremonies. Indians also admired it for the aromatic fragrance of its needles, which they burned as sacred incense; for the durability of its wood, which they found desirable for lance shafts, bows, and other items, and for the dark red seemingly dyed-in-blood color of its wood.

As incense, juniper ranks as one of the most important in Montana. Indians placed cedar leaves on fire to produce a sacred, purifying smoke in many religious ceremonies, including Peyote meetings, Sun Dances, sweatlodges, and other medicine rites. Cheyenne Indians believed juniper smoke beneficent for those fearing lightning and thunder, a belief based on their observations that lightning never strikes cedar trees. They believed that thunder was a terrible god taking the form of a great bird or a rider on a white horse. To alleviate fear of thunder, they burned cedar as incense.

This was often done in conjunction with a special ceremony in which they smoked tobacco, kinnikinnick, and red willow. Jim Spear, a Cheyenne, said that he had personally seen this ceremony at Bear Butte, near Sturgis, South Dakota. He said: "Many people can testify that there was much rain there. We used cedar and also the pipe. And in just that area it didn't rain, but everywhere else it did."

Juniper provided Indians with a vast storehouse of cures for common ailments. Flatheads believed that its sacred smoke purified the air and warded off illness. Nez Percés, Flatheads, Kootenais, Cheyennes, and Sioux made a tea from its boughs, branches, and fleshy cones which they drank for common colds, fevers, and pneumonia. Cheyennes used juniper tea as a vaporizer for colds and fevers, or they chewed the fleshy cones for relief from colds. Crow Indians chewed the cones to settle an upset stomach or to aid the appetite. Ailing Sioux and Kootenai enveloped themselves in juniper smoke to bring relief from colds, while the Cheyenne drank juniper tea for coughs and tickling of the throat.

Indians commonly turned to juniper for relief from arthritis and rheumatism, although the late Pete Beaverhead, a Flathead medicine man, claimed that no medicine was known to cure arthritis and rheumatism—really "difficult sicknesses." But at least to alleviate pain, they placed the affected parts into a warm concoction of juniper, claimed Pete. Blackfeet suggested a somewhat different cure for arthritis and rheumatism: they boiled juniper leaves in water, added half a teaspoon of turpentine, allowed it to cool, and rubbed it onto the affected part.

In the event that a child was not born right away, Cheyenne women used juniper as a medicinal tea. Crow women drank a medicinal tea after birth for cleansing and healing. The Cheyenne claimed the tea had sedative properties especially useful for calming down a hyperactive person. Kootenais drank it for sugar diabetes; one Kootenai claimed that Stony Indians drank this medicine to stop hemorrhages. Crows drank it to check diarrhea or to stop lung or nose hemorrhage. In the winter of 1849–50, Sioux Indians were plagued with a cholera epidemic, and many people were dying. Red Cloud tried various treatments to help his people and seemingly hit upon a good one by administering a tea of juniper leaves and bathing with it as well.

Flatheads doctored their horses with juniper. Pete Beaverhead explained that when a horse was obviously sick, cedar leaves were placed

in a can containing hot coals. The horse's nose was placed over the resulting smoke three times. This made the horse well, claimed Pete.

Early herbalists used the related common juniper, *Juniperus communis*, for a multitude of medicinal purposes. Oil of juniper, extracted from the fleshy cones, found usefulness as a diuretic, gentle stimulant, stomachic, and as a carminative in digestive disorders. It was also employed for scorbutic and cutaneous diseases, diseases of the bladder and kidney, and gonorrhea, to name a few. The herbalists mixed oil with lard and applied it to exposed wounds to prevent irritation from flies. In addition to the volatile oil, juniper contains resin, gum, lignin, wax, and salines.

A few Indians utilized common juniper, which is widespread in our region. Blackfeet used it to treat lung and venereal diseases and employed the related creeping juniper, *Juniperus horizontalis*, for kidney problems.

Indians made an excellent bow from juniper wood. In later times, Cheyennes considered that it furnished the best material for this purpose. They chose a small upright tree or splintered an appropriately sized stick from a larger tree if the grain was straight. They did not use the heartwood.

Description, Habitat, and Range

Rocky Mountain juniper is a tree or shrub, sometimes reaching fifty feet in height and much branched at the base. The leaves are scalelike, somewhat glandular, and arranged in twos. The fleshy, bluish cones are about one-quarter inch in diameter and mature the second year.

Juniper grows in the foothills of the Rocky Mountains from Alberta to Texas, and westward to British Columbia, Washington, eastern Oregon, Nevada, and Arizona.

Quaking Aspen
Populus tremuloides Michx.

Early pharmacists found in aspen properties similar to those of the willow. They employed aspen as a tonic and for intermittent fevers, as a diuretic in urinary infections such as gonorrhea, as an agent to destroy parasitic worms, and as a cure for jaundice, debility, and chronic diarrhea. They also found it a safe substitute for "Peruvian bark." They made this medicine as a liquid extract from spring or fall bark.

Flathead Indians drank the tea made from the bark for ruptures, cautioning that the bark must be collected by stripping it downwards from the tree, or one would vomit it out! Plains Indians, such as Cheyenne and Crow, found aspen logs suitable for constructing Sun Dance lodges. For others, it occasionally served as firewood.

Description, Habitat, and Range

Quaking aspen is a colorful tree, about ten to sixty feet high. Its bark is greenish-white, but with black markings on old branches. The leaves, which incessantly "quake" or blow in the wind, are one to two and a half inches long, about as wide, and are round-ovate and bluntly tipped, green above and paler beneath.

This tree inhabits generally moist and sunny areas; it grows in the colder regions of North America, especially the mountainous areas, from Alaska southward along the Pacific coast to Mexico, and east to Labrador and Virginia.

Kinnikinnick
Arctostaphylos uva-ursi (L.) Spreng.

W estern hunters called it larb. Canadian traders called it sacacommis or sagack-homi. Europeans called it bearberry. Nowadays Americans—Indians and non-Indians—call it kinnikinnick, a word borrowed from the Algonkian Indian language. Its translation means "that which is mixed," and refers to the use of its leaves as a smoking mixture.

Because early tobaccos had a very strong taste, Indians needed to "cut" or mix them with kinnikinnick or some other plant to make them milder for smoking. John Pelkoe, a Flathead from Camas Prairie, explained the process: "The best way to prepare the kinnikinnick leaves is to hang them up in the sweathouse. When the heat dries the leaves you just take it out in the open and then just squeeze them. You can then mix it with any kind of tobacco. It gives it a good flavor and makes it mild."

Luke Shortman, a Gros Ventre, told of a somewhat different way to prepare the smoking mixture:

In the fall time they pick a couple of big piles of it. They dry it out and then boil it. When they want to smoke they chop off some of this tobacco, a big heap full . . . and then the same with this kinnikinnick . . . They go about half and half . . . it all depends on the taste. If the tobacco is too strong, then they mix some more of this kinnikinnick until it is just right. Then that's what they smoke.

Because kinnikinnick does not burn readily by itself, Indians often smoked other plants with it. In addition to tobacco, Flatheads smoked the bark of red-osier dogwood or red willow (*Cornus stolonifera),* willow (*Salix* spp.) and the roots of false hellebore (*Veratrum viride*) and sweet cicely (*Osmorhiza occidentalis*).

Early explorers and mountain men became very fond of sweet-smoking kinnikinnick leaves. Lewis and Clark noted that Canadian clerks with the early trading companies smoked the leaves, which they carried with them in small bags.

Indians occasionally ate the rather dry, insipid, and mealy berries, but they apparently did not systematically gather and store them as they did other berries. Since the berries remained on the bush all winter, they could be gathered when needed to stave off starvation in hard times. Indians sometimes ate them raw, but preferred them fried. Remarked Adeline Mathias, a Kootenai: "We put the berries in a frying pan with

grease, hold it over a slow fire, and they pop like popcorn. One can eat it just that way."

Fried kinnikinnick berries, which taste sweet and agreeable, somewhat like apples, were also used as a condiment. Flathead Indians, for example, dried and powdered them for use as a condiment with deer liver. Adeline Mathias, who mixed them with liver to make a kind of pemmican, said: "The oldtimers would cook a whole bunch of the berries and mix it with cooked deer liver. They pounded down and rolled them into balls and made pemmican out of the works. They eat it that way."

Before the introduction of metal ware, Montana's Native Americans apparently boiled the berries to make a broth.

Non-Indians have apparently never eaten kinnikinnick berries as did the Indians. Lewis and Clark referred to them as "very tasteless and insipid." Others have spoken of them in disappointing and even disagreeable terms. Some, however, have reported them suitable for jellies, cobblers, pies, stews, and beverages.

Kinnikinnick also has healing powers, apparently recognized long ago. In the thirteenth century the Welsh "Physicians of Myddfai" used it; in 1601 the herbalist Clusius described it as a plant known to the early Roman physician Galen. Gerhard of Berlin recommended it for medicinal use in 1763, and eventually it became an official drug in nearly all pharmacopoeias.

Kinnikinnick's medicinal preparation comes from its leaves. They are best collected in the fall, preferably on a clear morning after the dew has dried from the leaves. They are dried by gentle exposure, either in partial shade out-of-doors or in a dry, well-ventilated room. The leaves are fairly rich in chemicals, including tannic and gallic acids and the organic glycosides arbutin, ercolin, and ursone. The medicine is administered as an infusion, useful chiefly as a mild astringent, a diuretic (to increase urinary flow), and for various bladder and kidney complaints. Its effectiveness is due to arbutin, which in urine hydrolizes to hydroquinone, a mild antiseptic and antiferment. It also strengthens and imparts tone to the urinary passages and was often used as a uterine excitant.

The medicinal properties of kinnikinnick did not elude some Native American tribes. The Northern Cheyenne Indians drank the infusion of the leaves for "persistent" pain in the back, a probable reference to kidney complaints. To bring about a cure, Cheyennes boiled the leaves, stems,

and berries and drank the infusion. They also wetted the leaves and rubbed them on the painful place. Cheyennes, known for their medicinal mixtures prepared from several substances, used kinnikinnick berries as part of a medicine for colds and coughs. Flatheads pulverized the leaves and applied the powder as a poultice on burns. Crow Indians pulverized the leaves and applied the powder to canker sores of the mouth. For earaches, Flatheads inhaled the smoke from the leaves through a pipe and then blew it into the aching ear with the detached pipestem.

Description, Habitat, and Range

Kinnikinnick is a small evergreen shrub. The trailing, multibranched, woody stems have reddish, scaly bark. Its leathery, shiny leaves are rounded at the tip and gradually taper towards the base: they have smooth margins and measure one-half to one inch long. The urn-shaped, waxy flowers are pink and are found in clusters at the end of the preceding year's branches. The bright red berries, which ripen in late summer, are smooth, glossy, and about the size of a pea, with a tough skin enclosing a mealy pulp and several seeds.

Kinnikinnick is found especially in poor soil, usually sandy or gravelly, and in our region often frequents ponderosa pine forests. Its range extends throughout the northern latitudes of North America, Europe, and Asia. In North America it occurs as far south as California, New Mexico, Virginia, and Illinois.

Other Common Names

Bearberry. Manzanita. Sandberry.

Chokecherry

Prunus virginiana L.

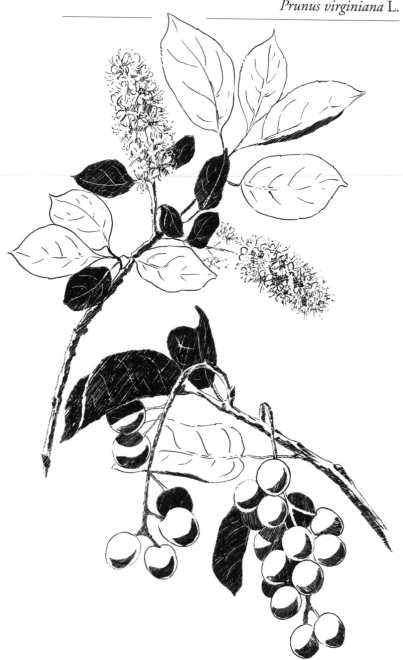

Can you imagine a plant having medicinal virtues, edible fruit, and yet being poisonous at the same time? Unlikely as it seems, the common chokecherry has all these attributes, and more.

Indian tribes of Montana ranked chokecherry as one of their most important berry plants, along with serviceberry, buffaloberry, huckleberry, and others. In fact, it was probably the most important berry plant to Cheyenne and other Plains-dwelling tribes. Indians harvested chokecherries in late August or early September, after the first freeze, which made them sweeter. Sometimes they ate a few berries raw, but the majority they sun dried and stored for winter use. First they pulverized them. To do this, women placed each chokecherry, pit and all, on a flat rock and smashed it with a stone pestle. The finely ground berry material was then formed into round cakes, each measuring several inches in diameter, and dried in the sun.

Indians saved most of the chokecherry patties for winter, thus forming one of the basic food staples in early times. Not only did they constitute the basic ingredient for pemmican, but they could be added to various kinds of soups and stews, to which serviceberries and other fruits, various roots, as well as some kinds of meat, such as venison, elk, or bison, were added. Indians might also eat the dried chokecherries by themselves, after overnight soaking.

Today's Indians have given up the pestle and flat rock for the more efficient meat grinder to pulverize the chokecherries. Although they still prepare a few chokecherries as their ancestors did, they more commonly use them to make a kind of pudding, to which they add sugar and flour.

Pioneers and explorers ate chokecherries, too, especially in times of hardship. Members of the Lewis and Clark Expedition ate them when other food resources became scarce. The mountain man Hugh Glass subsisted on them after having been mauled by a grizzly bear. The coming of "civilization" has not diminished the value of chokecherry; many kinds of wines, syrups, jams, and jellies can be made from them. To make jelly, any of the recipes for sour cherry jelly will do, although some people believe that a mixture of half chokecherry and half apple juice is better. Chokecherry butter is another delicacy. It is prepared by cooking the ripe fruit, straining out the seeds and skins, mixing with an equal quantity of plums or crabapples, and adding sugar.

Certain parts of the chokecherry are, however, poisonous. Scientists have found that the leaves, especially the young succulent shoots, and the pits of the fruits, contain a deadly cyanic acid. Losses to livestock from eating the leaves have occurred, and it is reputed that people have died from eating the pits. But Indians of this region have been eating chokecherries, pits and all, for centuries, with no apparent cases of poisoning. Maybe the cyanide poison in the fruit is too diluted to cause poisoning in most humans, or perhaps the poison evaporates in the Indian drying process.

To chokecherry's list of "gourmet qualities" can be added its remarkable medicinal properties. As with many other medicines which the Native Americans used, this one has found its way into the hands of the non-Indian. Not only has it been used in folk medicine, but it has been discovered by modern science, and as such is listed in various pharmaceutical and herbal journals and reference books.

Most noteworthy of the medicinal virtues realized in our region was chokecherry's ability to relieve various kinds of stomach complaints, such as diarrhea and dysentery. Flathead, Kootenai, Gros Ventre, and Crow Indians, to name a few, made a medicinal tea from chokecherry bark to bring about a cure. Flatheads and Kootenais believed it to be one of the best of their remedies. Cheyennes made a similar medicine from pulverized, unripened chokecherries for diarrhea. Early pioneers used this remedy, too. When the Lewis and Clark Expedition camped on the upper Missouri River, Captain Meriwether Lewis became ill with abdominal cramps and fever. He made a tea from chokecherry twigs and was well the next day.

The drug from chokecherry bark was introduced into American medicine about 1787 and appeared in the *United States Pharmacopoeia* about 1820. It was brought to the attention of the British medical society in about 1863. Modern pharmaceutical references mention the medicinal values of the bark as useful in treating "gastric atony and general debility."

Other European and American pharmaceutical uses of chokecherry parallel some Indian uses. Flatheads used this same medicinal tea for intestinal worms. So, too, did early pioneers. Crow Indians used the infusion of the bark for cleansing sores and burns, but only certain tribal members had the "authority" to perform the medicinal application. Flathead Indians, who used chokecherry as an eye medicine, warmed the

resin from the bark, strained it, and allowed it to cool, before placing into sore eyes.

Cheyenne Indians used chokecherry limbs to make arrow shafts and bows, while the Crows used the wood for tipi stakes and pins. They also mixed the sap with the neck portion of certain animals and made a glue, especially useful for attaching feathers on arrow shafts. This same sap was also mixed with different colored clays to make permanent paints for Indian designs on suitcases, shields, and other items.

Crow Indians, virtually surrounded by enemy tribes in earlier days, learned of several ways to conceal their presence. They made their daytime campfires with the wood of chokecherry, a wood which, they claimed, makes no smoke.

Description, Habitat, and Range

Chokecherry is a small tree or large shrub standing from fifteen to twenty feet tall. Its brilliant green, oval leaves are one and a half to four inches long. In May or June it bears showy white blossoms at the end of the upper branches. During the summer the flowers develop into purplish-red fruit, each measuring almost one-half inch in diameter. As with other cherries, there is a hard, stonelike portion called the pit within the fleshy outer covering.

Chokecherry is usually found in moist soil, especially along creeks and ravines, but also in open wooded areas of valleys, foothills, and mountainous slopes. This is one of the most widely distributed shrubs in North America but especially common in the northern Rockies and northern plains.

Prairie Sagebrush
Artemisia ludoviciana Nutt. and other species

Cheyenne Indians probably used prairie sage, or "man sage" as they called it, in more religious ceremonies than any other plant. Indeed, few of their ceremonies seem to be missing this sacred sage. They spread it along the borders in most, if not all, ceremonial lodges, the tops of the stems pointing to the fire. They regarded this fragrant herb as having the power to drive away bad spirits, evil influences, and ominous dreams of

sick persons. Its use for purification was widespread. Cheyennes generally burned sage leaves as incense to purify implements, utensils, or themselves in various ceremonies, or they purified one who had committed a taboo by wiping that person with a bundle of sage. Certainly other Plains tribes found similarly purifying qualities in it.

Many are familiar with the Indian contrary warriors, those who did everything by opposites and unintentionally attained this post through fear of thunder. Cheyenne contraries found man sage beneficial for purification purposes. When they left someone's lodge, they passed the plant over the ground to purify it; if their lances, which protected them from thunder, happened to touch anyone, they rubbed sage on that person; if these same lances touched their horses, which usually was the case when they rode, they wiped their horses with sage before turning them loose to pasture. After they ate from a dish, they wiped it, too, with purifying sage.

Cheyennes used sage on numerous ceremonial occasions. Sun Dancers prepared beds of sacred sage on which they stood or rested during the entire ceremony, constantly drawing power from it. Sun Dance priests incensed the participants—first the Sacred Woman, the Pledgers, and finally the Dancers—with its purifying smoke. Sun Dancers had their eagle-bone whistles wrapped with sage to prevent thirst. Priests of the Sacred Arrow ceremony similarly incensed themselves in man sage smoke. Sun Dance participants dipped sprigs of sacred sage into kettles of food which they carried around the lodge, making offerings to the four cardinal points, the altar, and the center pole. They used these sprigs as paint brushes to ceremonially paint the dancers, and to wipe off paint afterwards, too. Dancers wore wreaths of sage around their arms, waists, and heads.

When fasting in the hills, Cheyenne men lay on beds of white sage, and before going to battle, warriors purified their shields by passing them over sage smoke four times, then moving them down the body four times, the last time putting the shields on their arms.

In "Standing Against Thunder," a ceremony designed to allay fear of thunder, the participant laid a half-circle of man sage around a lone juniper, forming a sacred pathway which one walked upon during the sacrifice; through this practice, he derived sacred blessing. In the sweatlodge, men used sprigs of sage to sprinkle water on the rocks and to beat their bodies. During Peyote meetings, participants first purified themselves by rubbing

man sage over the body believing it made them immune from sickness. Crow Indians also used this sage in nearly every one of their ceremonies. Micky Old Coyote, a Crow, maintains that the pungent, purifying plant represents the future.

Prairie sage was important in the Indians' pharmaceutical *materia medica.* Flatheads brewed a strong, bitter-tasting tea for colds, or they used the solution externally to treat bruises or itchiness. In the latter treatment they might mix rose water solution with sage. Kootenais similarly boiled the plant to make a solution to dry up sores. For treatment of sores, Crows made a salve by mixing it with neck fat; they also prepared a strong infusion which they applied as an astringent for eczema, and they used it for underarm and foot perspiration and odor. Cheyennes crushed the leaves, which they used as snuff for sinuses, nose bleeding, and headache. Gros Ventre Indians made a medicinal tea for high fever, and frontiersmen drank it as a remedy for Rocky Mountain spotted fever.

Montana's Native Americans used other species of sage for various purposes. Flathead Indians used tarragon, *Artemisia dracunculus,* to reduce swelling of feet and legs. They boiled the foliage and, when the solution was lukewarm, placed the feet and legs into it, while rubbing the affected parts with the boiled plant. Flatheads also applied the dried and powdered foliage on open sores. Crow Indians, who call it wolf's perfume, made an infusion from the stems and leaves, strained it through a cloth, and applied it as an eyewash, as for snow blindness. They used the remaining leaves as a poultice on the eyes. The Kootenai believed that their culture hero, Coyote, smoked this sage as tobacco.

Cheyenne and Sioux Indians called fringed sage, *Artemisia frigida,* "women's sage or medicine." Although the Cheyennes didn't seem to know why, the Sioux gave it this name because the women used it to make a tea to correct menstrual irregularity. The Sioux also used the decoction for bathing. Kootenais drank a concoction for chest trouble; this caused vomiting—which, they believed, was beneficial. They also drank it for tuberculosis, burned it as a smudge for mosquitoes, and used its smoke in religious ceremonies.

Indians got some kinds of sage from outside of Montana's borders. Flatheads procured a certain kind from Spokane Indians in Washington from which they made a concoction they either drank as a tea for colds or used externally as a hair rinse for dandruff. Members of the Cheyenne

Chief Society got a species from Texas, which they used to light their pipes.

Flatheads drank a tea made from big sagebrush, *Artemisia tridentata*, for colds and pneumonia, and sometimes they used it for fires when other kinds of firewood were not available. Nez Percés gathered an unidentified species from the Salmon River country, the bark and leaves of which they boiled to make a tea drunk in alternating two-week periods to treat tuberculosis. Cheyennes burned a large species of sage beneath a horse's nose for "medicine."

Description, Habitat, and Range

Prairie sage, *Artemisia ludoviciana*, is an aromatic, silver-colored perennial herb standing one to three feet tall. The leaves are linear or are slightly to deeply three-lobed. Its small, yellowish flower heads are grouped together along a sometimes highly branched flowering stalk which grows from twelve to thirty inches high. The plant is common to foothills, plains, and prairies of western North America, from Mexico to the prairie provinces of Canada, especially on sandy, gravelly, or rocky loam.

Tarragon or sagewort, *Artemisia dracunculus*, is a green biennial and often shrubby herb with closely grouped stems, often reaching heights of twenty to forty inches. Its numerous yellow flower heads are borne in cup-shaped groups at the upper ends of the stems, its leaves small, narrowly or broadly linear. It is found in prairie regions from Manitoba to British Columbia, and south to Texas.

Fringed sage, *Artemisia frigida*, is an aromatic perennial herb, from four to twenty-four inches tall, although most of the many-divided, soft, and silky leaves are clustered near the ground. This is a wide-ranging species, from Mexico north to Canada, Alaska, and to Asia and northern Europe. It is generally found on dry hills and plains.

Big sagebrush, *Artemisia tridentata*, is a stout, woody shrub from two to ten feet tall. Its gray-green leaves are three-parted at the tips and up to one inch long. This variable, wide-ranging species is commonly found in the west, especially in the Great Basin region and intermontane valleys, where it inhabits dry, cold prairies.

Bitterroot
Lewisia rediviva Pursh

Montana chose a deserving state flower in the lovely bitterroot. It has lent its common name to a mountain range, a valley, and a river, while it has borrowed its scientific name, *Lewisia*, from the famous explorer, Captain Meriwether Lewis. Few plants rival the radiant beauty of the bitterroot, whose flowers paint spring foothills and prairies with colorful hues of pink and white.

The renowned Lewis and Clark Expedition was the first group of explorers to encounter this exquisite plant. On August 22, 1805, the expedition made camp near the headwaters of the Beaverhead River in the Big Hole Valley of western Montana. Druillard, expert hunter of the corps, met a small band of Indians who, after a scuffle over an attempt to steal his rifle, fled, leaving behind their baggage. Captain Lewis said that it contained:

> . . . a couple bags woven with the fingers of the bark of the silkgrass containing about a bushel of dried serviceberries, some chokecherry cakes, and about a bushel of roots of three different kinds dried and prepared for use which were folded in as many parchment hides of buffalo . . . one species of the root was fusilform about 6 inches long . . . another species was much mutilated, but appeared to be fibrous. The parts were brittle, hard, and of the size of a small quill, cylindric, and white as snow throughout, except some small parts of the hard black rind which they had not separated in the preparation.

Captain Lewis later learned that the Indians boiled these roots for food; he tried them and found that they became perfectly soft by boiling, but unfortunately had a bitter, nauseous taste. Lewis then gave the roots to some Indians, who greatly appreciated what to them was a savory treat. Lewis asked to see the plant, but the Indians told him that it was not to be found where they presently were—the Lost Trail Pass area, near the descent into the valley which now bears this plant's name.

The scientific community learned about bitterroot as a result of President Jefferson's instructions to Meriwether Lewis to collect information about Indian food plants. The expedition collected large quantities of plants during the westward journey, but they were unfortunately lost when a canoe upset its cargo and another cache molded. On the return trip in 1806, Lewis collected one hundred and fifty specimens, including thirty-two from Montana; these reached the east

coast. Among these was a specimen of bitterroot collected on July 1, 1806, at the mouth of Lolo Creek, at the place they called Traveler's Rest, near Missoula. By horseback, boat, and stagecoach, this specimen found its way some three thousand difficult miles to reach the Academy of Natural Science in Philadelphia. The noted botanist, Fredrich Pursh, scientifically named bitterroot *Lewisia rediviva*, thus honoring Meriwether Lewis and describing the fact that a gardener was able to resprout the plant from the dried root.

Not long after this, David Thompson, an early Canadian trader and geographer, established posts among various western Indians. He soon began trading with them for food and furs and noticed that they carried these nutritious roots with them on journeys. French Canadian hunters and Northwest Company traders soon became familiar with the plant. French Canadians called it "raceme amere," literally, "bitterroot."

David Douglas, the early botanical explorer who visited the Northwest in 1826 and 1827, found Indians digging bitterroots in the Spokane, Flathead, and Salmon River valleys. The Jesuit missionary, Pierre-Jean De Smet, reported natives digging the roots along the Palouse River in Washington in the 1840s, while Granville Stuart, one of Montana's leading pioneers who arrived in the late 1850s, said that mountaineers he encountered were very fond of them. He testified that he ate them only when he was very hungry. Despite the fact that these early naturalists, explorers, and pioneers ate bitterroot, they seldom gathered the food themselves; they preferred trading with Indians to obtain a supply.

Montana's first inhabitants, the Indians, learned of bitterroot long before the white man did. Flathead Indians, who perhaps valued its root more than any other tribe, have given us a story explaining how man came to possess this edible and beautiful plant.

Long ago, as the story goes, in what we now call the Bitterroot Valley, Flathead Indians were experiencing a famine. One old woman had no meat or fish to feed her sons. All they had to eat were shoots of balsamroot, and even these were old and woody. Believing that her sons were slowly starving to death, she went down to the river early one morning to weep alone and sing a death song. The sun, rising above the eastern mountains, heard the woman singing. Taking pity on the old woman, the sun sent a guardian spirit in the form of a red bird to comfort her with food and beauty. The bird flew to the old, gray-haired woman and spoke softly.

"A new plant will be formed," said the bird, "from your sorrowful tears which have fallen into the soil. Its flower will have the rose of my wing feathers and the white of your hair. It will have leaves close to the ground. Your people will eat the roots of this plant. Though it will be bitter from your sorrow, it will be good for them. When they see these flowers they will say, 'Here is the silver of our mother's hair upon the ground and the rose from the wings of the spirit bird. Our mother's tears of bitterness have given us food.'"

Apparently Kootenai Indians did not know of the bitterroot until rather recently, about the time they acquired the horse. They probably learned of its edibility and storage qualities from their southern neighbors, the Flatheads. To explain the presence of the plant in the northern part of their range, the Kootenai claim that one time a man traveled south and married a woman. She came north to live with him, and brought camas and bitterroot, but not liking it there, she returned home. On her way back she threw away the bitterroot at Cranbrook and Tobacco Plains, British Columbia. This is why you can still find it there today, claimed the Kootenai. Interestingly, she liked camas better, and took that with her farther south; this explains the absence of camas farther north.

Among Flathead and Kootenai Indians of western Montana, bitterroot was the most important root crop. Kootenais dug their annual supply at Tobacco Plains and the Little Bitterroot Valley. Living in the Bitterroot Valley, Flatheads had access to the best bitterroot ground in the region. Many observers noted the great bitterroot-digging activities near what is now Missoula, Montana. Each spring Flathead, Kalispell, Pend d'Oreille, Spokane, and Nez Percé gathered here to dig this prized root. Occasionally Blackfeet raiders took advantage of this peaceful gathering and plundered its participants.

Angus McDonald, who built Fort Connah for the Hudson's Bay Company in the Flathead Valley in 1847, gave one of the first descriptions of such an encampment and an enemy raid which it suffered.

> The camp was pitched on the plains of the cold spring, that plain which is on the left of the river of Hell's Gates as it issues out from the defile of that name: that plain where gathered the red man of past age to hold their annual races, horses and afoot in short or long heats, to any distance they pleased. The Hell's Gates mountains towered east of and over the plain in

solid granites covered with luxuriant grasses and primeval forest to a height that overlooked the three valleys of the Bitterroot, Hell's Gates and the Missoula. On that blue, pineclad top, the enemy was wont for months to set spying any mortal that moved in those beautiful valleys.

A small camp of Flatheads was pitched by the cold spring of said plain. A little group of men inside told the daring and dire incidents of their lives as they passed their pipe. Another group outside scanned the green and bold mountain steeps in front of them, and now and then looked to Mount Lolo, remote and grey, looming like the evening star to their west.

Four buffalo bulls were observed grazing on the steep of the Hell's Gates Mountain. The men were soon off on their best buffalo horses in swift pursuit of the bulls. When they stood where the bulls were, they could find no trace of bull or cow. No search could discover them. Other signs were there, and the terrible shape of the human foot in the mountain sand soon told them the meaning of it. Turning to overlook the camp, which in its oblique distance was yet clear below them, they saw the enemy as cleverly slaying the camp. Stung by the deception and the truth of it, they whipped their horses over the plain toward their camp. Before they reached it the enemy's work was done, and the camp slain before their eyes.

Flatheads and Kootenais honored bitterroot with the First Roots Ceremony. They practiced this rite in early May to insure a good harvest and to officially begin the root-digging and berry-picking season. With the Kootenai, an elderly woman assumed leadership of this important event. She must never have been visited by misfortune. When she determined that bitterroots were ready for harvest, she brought some back to the chief's lodge. The chief then announced that the digging celebration might begin. The women brought their digging sticks and parfleche bags to the chief, who gave a prayer for their safety. Led by this elderly woman, the party set out for the gathering site. Only a few men went to serve as guards against attack by an enemy or grizzly bear.

When they arrived at the first bitterroot, they performed the ceremony. The leader stuck her digging stick in the ground at the base of the selected plant, and the other women followed. All then knelt down and prayed for protection against harm. The leader uprooted the plant, the other women doing likewise, and thus formally opened the bitterroot-digging

season. They gave the first root to the chief, and thereafter the women were allowed to dig their own. No one was allowed to dig before the First Roots Ceremony; to do so would result in a small harvest.

The next day, normally Sunday, the Kootenai held a feast, cooking bitterroot in a broth of boiled blue grouse and deer which the men had hunted the day before. The chief then gave a prayer of thanksgiving, after which the food was distributed among the people. After the feast, family groups scattered to various bitterroot sites, while the men continued to hunt and fish.

The Flathead First Roots Ceremony was very similar, but two or three women officiated at the ceremony. Like the Kootenai ritual, the Flathead event lasted for two days. The first day they ceremonially dug bitterroots; Agnus Vanderburg said twelve young girls assisted. The next day they held their feast. Flatheads believed that bitterroots would become small and scarce if this ceremony was not observed.

Indians used a special kind of digger to remove the roots from the ground. In old times the Kootenai had two kinds of bitterroot diggers, although they preferred a tool made from a three-foot-long willow stick. They fire-hardened one end and bored a hole through the other, through which a deer antler handle was fastened. They made the other kind of tool from elk antlers. This digger was about fifteen inches long, with the crotch of a prong at one end used as a handle. In recent time, Indians have had blacksmiths make them iron bitterroot diggers. These are about three feet long. One end is slightly curved and pointed; the other is bored to receive a wooden handle.

Indian women dug bitterroot before the plant bloomed, because after this time the brownish-black bark layer on the root does not easily slip off the white, inner portion. After they removed a plant from the ground, they twisted off the vegetative top that was not used. After digging for the day, they peeled and washed the roots. Some removed the inner core or "heart," believed to be the part responsible for much of the bitter taste. The roots that the women did not immediately use were spread out on hides or old lodge covers to dry for one or two days. Often they kept them for a year or two before eating, in which case they became less bitter.

Kootenai packed dried bitterroots in parfleche bags that were cached on tree platforms. Gathering bitterroot was a tedious, although not

difficult, task. Women often worked three or four days to fill a fifty-pound sack. Each woman gathered at least two sacks, enough to sustain two people through the winter. A sack of bitterroots was worth a lot. C. A. Geyer, an early botanical explorer, said that one sack was worth a horse, but he didn't say how big the sack nor how good the horse!

In old times, Indians boiled bitterroots in watertight baskets by dropping very hot rocks into the water; later they used the white man's iron kettle. They liked to steam them, too. To do this, they placed a lattice-work of small twigs at the bottom of a pot to keep the roots out of water. Only a few minutes were required to prepare them. Indians ate them plain, mixed them with berries like serviceberries or huckleberries, added them to meat or bone marrow, or used them to thicken gravy. For a sweet treat they added powdered camas bulbs. In more modern times, Flatheads ate bitterroots with milk or cream and sugar. Indians regarded bitterroots as a luxury food, offering variety to their otherwise meaty diet. They often carried them on trips, however, since they are light and easy to carry but quite nutritious.

Some Indians found bitterroot a useful medicine. Flatheads, apparently adapting a medical practice from Cree Indians, boiled the roots to make a tea drunk for the pain of heart trouble and pleurisy. Flathead and Nez Percé women ate bitterroots or drank a tea made by boiling the roots to increase milk flow after childbirth. Nez Percé thought the plant good for impure blood, which they believed caused skin problems and diseases.

Description, Habitat, and Range

Bitterroots—white to pinkish flowers, each about two inches across—appear to be leafless. But the fleshy, one- to two-inch leaves appear before the flowers in early spring, soon after the snow melts. They wither away by the time the flowers bloom, generally in early June.

Bitterroot grows in dry, rocky soil of valleys, plains, and foothills, from British Columbia south through Montana, California, and Colorado. It is especially abundant in western Montana.

Ponderosa Pine

Pinus ponderosa Dougl. ex Laws. & Laws.

Have you ever considered eating a pine tree? Perhaps you have not, but long ago Indians in our region regularly peeled the bark to eat as a sweet, delicious food. Few people today seem to know about this, despite historical accounts describing these edible properties. As early as 1805, for instance, Sacajawea told Lewis and Clark that certain species of trees had edible barks and that Indians cherished them as food. While the Lewis and Clark Expedition was camped on Lolo Creek, in western Montana, they recorded ". . . the Indians have peeled a number of Pine for the under bark which they eate at certain Seasons of the year, I am told in the Spring they make use of this bark." Kootenai, Flathead, and other tribes in the region found ponderosa pine bark a nourishing treat. Although no longer stripped of their edible bark, some pines still bear large scars, telltale signs of the early Indians' fondness for it.

Before the Kootenai harvested the bark, they performed a preliminary ceremony. William Gingros, as recorded by Thain White, described it:

When old timers used to do this peeling they did it in the spring, usually on and after the first Sunday in May. They held a celebration in which all the Kootenai in the old days used to participate. Now the ceremony is nearly died out. Usually a day before Sunday they held a gathering of the people. They prepared for the Sunday morning when it was necessary for them to pray to the digging sticks which were used for digging bitterroot. After the head women discovered that the bitterroot was ready to dig the others in the group peeled trees for a noonday feast. Of course, if she found out that the bitterroot was not yet ready to dig then the whole affair was postponed. In the old days if any person peeled trees before the bitterroot was ready it was believed it would bring bad luck. The offender was not punished by the people, but the spirits would somehow do that.

Before Indians harvested large quantities of bark, they first selected a test tree to determine whether it was ready for eating. They removed a vertical strip and sampled the sap for its sweetness and flow. Women, not men, harvested ponderosa pine bark. They chose a day that was cloudy and cool—conditions which made the sap run well. Often assisted by their children, these expert bark splitters went to where the bark could be most easily harvested, usually close to camp.

Indian women employed a special tool to remove the bark from the tree trunks. It was usually a wooden stick, often of juniper, which they flattened at one end as a chisel. These were strong tools, but limber enough to follow the curvature of the trunk when plied under the bark. They also used the rib bone of an elk or bison as a debarking tool.

Judging by the thickness of ponderosa pine bark, it must have been a difficult job to peel and remove it from the trunk. Certainly it required the stamina of strong women to pull the larger pieces off. Once they found a suitable tree for debarking, they removed a large piece, although usually from one side of the tree only so as not to kill it.

Once they removed the bark, the women used another tool to separate the sweet, edible inner bark from the outside layer. In prehistoric times Kootenai Indians made a special kind of scraper from mountain sheep horns. By the 1890s the K. C. Baking Powder can came into the region and from it Kootenais fashioned a new, spadelike instrument superior to the horn knife. Placing the strips of bark on the knee or on the ground, the women sliced away from their bodies and separated the inner bark

from the outer. Indian women normally did this work at the harvest site because the entire bark, often exceeding a hundred pounds, was too heavy to carry back to camp.

Indians ate some of the sweet inner bark immediately, finding it a delicious treat, especially after a long winter. They kept the remainder for a brief storage period, normally only for a few days, since it soon dried out. However, they did have ways to preserve it for somewhat longer periods. The bark could be rolled into little balls and packed with green leaves in bags, parfleches, or bark baskets for storage. Similarly, the bark was slit and tied into knots and then placed in parfleches with green leaves or grass to prevent drying.

The practice of eating the inner bark from trees is old in the West. Although many tribes certainly ate inner bark, it seems that the Indians of the Rocky Mountains relished this annual sweet more than did others. The removal of edible bark from trees continued on the Flathead Reservation in western Montana until shortly after 1900, when officials at Dixon discouraged the practice because it was deemed injurious to commercial species of timber. This policy, apparently supported by the tribal council and the principal chiefs, came about in 1908 and 1909. The action was coupled with the opening of the reservation to non-Indians in 1910; this led to the establishment of stores which sold sugar in quantity, thus replacing the age-old practice of scraping edible bark from trees. With the possible brief reversion to its use during World War I, when there was a sugar shortage, it seems probable that by 1920 the practice had died out entirely.

Flatheads and other people variously used ponderosa pine as medicine. One such remedy reputedly cured boils and carbuncles. Bob Adams, a Flathead from Camas Prairie, still used it, as revealed by this story:

> I got a boil on my seat about a month ago. It was so bad that I couldn't sit down straight! I thought that I would have to go to the doctor and have it lanced. But I was afraid that he would cut the wrong thing! So we went up and got the white pitch from the bull pine and some Oregon grape leaves. We then put this pitch by the stove until it dripped. When it was cool enough we put it on the boil, then Oregon grape leaves. We then taped it and let it be. I went to sleep. When I awoke the boil had busted. It is a lot better than going to a doctor.

Captain Meriwether Lewis made a similar use of this medicine for an abscess when the expedition's drug supplies ran low. On June 5, 1806, his journal read: "I applied a plaster of salve made of the resin of the long leafed pine, bees wax and bear's oil mixed, which has subsided the inflammation entirely. . ."

Flatheads also used it for rheumatism and backache. They mixed pine pitch with melted animal tallow or, more recently, lard and applied it as a poultice spread on buckskin or canvas to the aching area.

There were other uses as well. For dandruff—as Mitch Small Salmon, a Flathead, explained—the pointed ends of the needles were jabbed into the scalp. This was believed to kill germs. To facilitate the delivery of the placenta, Flatheads placed heated needles on the abdomen of a woman giving birth. They also used pine boughs in the sweatlodges to "beat" one suffering from muscular pain. Cheyennes chewed the pitch as gum, and it is likely that other tribes did, too. They also used the pitch in the manufacture of bone and wooden whistles and flutes, in which case it was placed in the hollow ends. For the sake of vanity, Cheyennes plastered their hair in place with this same pitch, while Nez Percés and Crows used it as glue. Finally, Nez Percés made torches with the pitch; they were burned in semisubterranean houses to give light and by night to guide fishermen.

Description, Habitat, and Range

This majestic evergreen, Montana's official tree, measures from sixty to two hundred feet tall. Its spreading or sometimes drooping branches form a narrow cylindrical crown. The lower limbs gradually die as the tree matures. The bark of young trees is dark and fissured, while that of older trees is thick and broken into long reddish-brown plates. The stout needles, which measure from eight to ten inches, are grouped into bundles of threes. The reddish-brown, three- to five-inch cones are elliptical to ovoid in shape.

Almost everywhere this drought-resistant tree forms a boundary between the grasslands or shrublands below and the more dense forest belt above. It often forms beautiful, frequently pure parklike stands on open plains and occurs throughout the West, from southern British Columbia to northern Mexico and as far east as Nebraska.

Lodgepole Pine

Pinus contorta Dougl. ex Loud.

Everyone recognizes the skin-covered tipi in which most Montana Indians once lived. Lodgepole pine most often supported these portable dwellings. Indians, especially Plains tribes, often had to travel hundreds of miles to get poles from higher mountain regions or they frequently traded with other tribes to obtain them. They wore out the poles quickly, however, since they dragged them over the prairie when they moved camp. Consequently, they had to replace them every year, normally during the summer months. Women cut and peeled the poles, leaving them to dry in the sun. They gathered from twenty-five to thirty poles, each measuring approximately twenty-five feet long, for every tipi. They are remarkably strong, yet light and easy to handle.

Lodgepole pine also provided food for the Indian. Flatheads and Kootenais ate the inner bark, or cambium, which they scraped off slabs of the easily removed bark. But some Flatheads warned that eating too much caused a bellyache. Flatheads also ate the nourishing seeds and chewed the pitchy secretions on the bark as gum.

Indians occasionally employed lodgepole pine sap for medicinal purposes. Pete Beaverhead, a Flathead, used it to allay bothersome burns and boils. For burns he heated sap until it turned black, then added one part of bone marrow to four of sap. He mixed this with his hands and moulded it into flat cakes used as a poultice. For boils, he made another poultice by mixing the sap with red axle grease and Climax chewing tobacco! Finally, Kootenais suggested eating the sweet inner bark for tuberculosis.

Description, Habitat, and Range

Lodgepole pine is highly variable in growth form, from twisted and shrubby types along the Pacific coast to slender inland types up to one hundred fifty feet tall. The bark is thin and scaly. The stiff needles are from one to two and a half inches long and are grouped in bunches of two. The roundish cones are small, measuring only from one to two inches long.

Lodgepole pine grows from sea level to eleven thousand feet in elevation from the Yukon through coastal Alaska and British Columbia, and from Washington, Oregon, and California east to the Rocky Mountains.

Indian Ice Cream

Shepherdia canadensis (L.) Nutt.

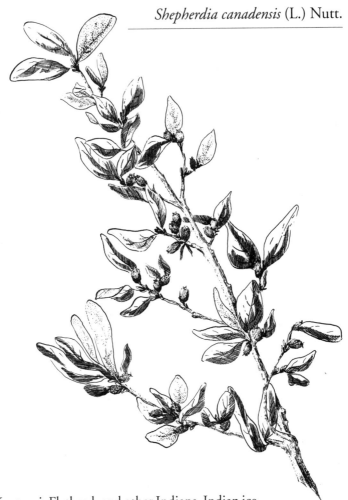

To Kootenai, Flathead, and other Indians, Indian ice cream, also known as Canada buffaloberry or soapberry, constituted an exquisite dessert. The manner of gathering and preparing them was basically similar everywhere: Indian women gathered them when they ripened in mid-August. They thrashed the berry-laden bushes with a stick, knocking the berries on pieces of hide and canvas. The Kootenai name for the fruit literally means "thrashberry," in reference to this manner of gathering them. They then cleaned them from the leaves, twigs, and other refuse. Indians ate some fresh, while they sun dried others for future use.

To prepare "Indian ice cream" from these berries, Indian women placed a small number of them into a bowl with a little water, then used a special stick with some grass tied on one end to beat the fruit. The resulting concoction became frothy or foamy and was relished by the old timers. More recently, Indians have added sugar to this otherwise insipid treat. Special care should be taken during preparation to avoid using any type of greasy cookware, warned some Indians, since this prevented adequate foaming.

Old-time Indians must have had a great deal of eye trouble, judging by the number of remedies extolled for sore eyes. Flathead and Kootenai Indians found the solution made from the bark of buffaloberry one of their favorites.

Description, Habitat, and Range

Buffaloberry shrubs, which stand from two to five feet tall, have brown, scruffy branches. The leaves are elliptically shaped, arranged in pairs, and measure from one-half to two inches long; they are green on the upper surface and silvery to brown-scruffy beneath. The minute, inconspicuous flowers are found in clusters at the leaf nodes. The berries are brilliant red and measure approximately one-quarter inch in diameter.

Buffaloberries are found in moderately dry to open wooded areas. This is a wide-ranging species, occurring throughout most of the West, from Alaska to Oregon and east to the Atlantic coast.

Other Common Names

Canada Buffaloberry. Soapberry.

Green Ash

Faxinus pennsylvannica Marsh.

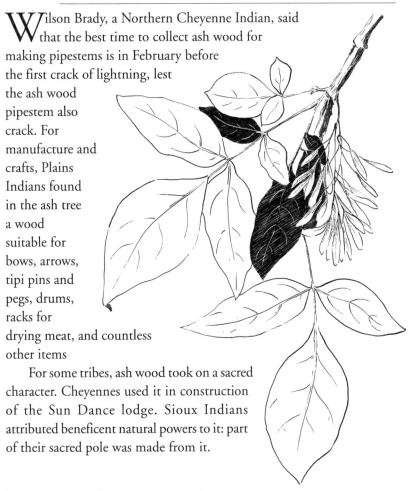

Wilson Brady, a Northern Cheyenne Indian, said that the best time to collect ash wood for making pipestems is in February before the first crack of lightning, lest the ash wood pipestem also crack. For manufacture and crafts, Plains Indians found in the ash tree a wood suitable for bows, arrows, tipi pins and pegs, drums, racks for drying meat, and countless other items

For some tribes, ash wood took on a sacred character. Cheyennes used it in construction of the Sun Dance lodge. Sioux Indians attributed beneficent natural powers to it: part of their sacred pole was made from it.

Description, Habitat, and Range

The ash is a medium-sizes tree, thirty to sixty feet tall. Its leaves are pinnately divided into five to nine leaflets, these being ovate to oblong-lanceolate in shape. The mature fruits are reddish-brown and membranous.

Green ash is found principally along streams, and, in Montana, in the eastern portion of the state. It ranges northeast to Nova Scotia and south to Florida and central Texas.

Western Red Cedar

Thuja plicata Donn ex D. Don

Light and easily worked, western red cedar wood and bark provided the mountain-dwelling Nez Percé, Flathead, and Kootenai Indians with one of their finest materials for construction. Consider canoes and rafts, for instance. Nez Percé Indians regarded western red cedar as providing the best possible wood for the purpose. Some claimed that only driftwood was used. If this was true, it certainly saved them a great deal of labor in felling this large tree. They used fire to hollow out the inside, then trimmed and smoothed the rest with an adz. Kootenai Indians generally made their canoes from birchbark, but they used cedar for the frame. Nez Percés built rafts of cedar, using them to carry equipment on hunting trips, especially before they acquired the horse.

Indians employed cedar wood for other purposes as well. Nez Percé Indians fashioned cradle boards from it. To prevent shrinkage, they stuck cedar slivers through drying meat in order to suspend it on poles. Kootenais made bowls from cedar wood, the larger ones being used for cooking.

Although Montana Indian tribes did not generally develop the art of basketry to the sophisticated extent that other tribes did, they fashioned

some rather interesting and useful containers from cedar. Nez Percés and Kootenais made baskets from fine cedar roots. One report claimed they gathered the roots in spring, but another stated that they collected them in August or September. Kootenais split these fine roots in two and peeled them. They prepared two sizes of roots, the larger ones to form coils and the smaller ones to sew the coils together. They sewed and bound two strands alternately around the coil to make the baskets firm and tightly woven because they wanted them watertight for cooking. Often they dyed the baskets black and green, the former color coming from wild carrot root and the latter from a type of green mountain grass.

Cedar bark gave Indians another material for manufacture. Flatheads made bark baskets. They made one type of container by weaving strips of bark into any shape they desired, using the finished product to store berries, since the berries tended not to rot in a container in which air was free to circulate. They also shaped whole sheets of bark into storage containers. Kootenais made a larger storage trunk from cedar bark, and before the introduction of the tipi, Nez Percé Indians made lean-to shelters from the material, especially when they were camping in the mountains. They also used cedar bark to cover the roofs of their early, semi-subterranean houses.

Indians used cedar only occasionally for medicine. Nez Percé Indians drank a tea brewed from the boughs to cure coughs and colds, adding honey or sugar if giving it to children, since cedar tea has a bitter taste. Sometimes they made a medicine for diarrhea from the leaves.

And finally, Catholic Flathead Indians substituted cedar boughs for palms on Palm Sunday.

Description, Habitat, and Range

Western red cedar is a large forest tree, occasionally reaching heights of one hundred and fifty to two hundred feet. It has a strongly buttressed and tapering trunk, five to eight feet in diameter. Its small, scalelike, bright green leaves form flat, lacy sprays, pendulous at the ends. The cones, one-eighth of an inch long, are clustered near the ends of the branches.

This tree inhabits moist sites along the Pacific coast from southern Alaska south to northern California and west to Idaho, British Columbia, and Montana, from sea level to seven-thousand-foot elevations.

Smooth Sumac
Rhus glabra L.

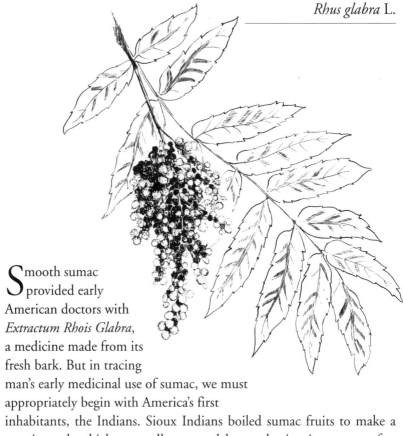

Smooth sumac
provided early
American doctors with
Extractum Rhois Glabra,
a medicine made from its
fresh bark. But in tracing
man's early medicinal use of sumac, we must
appropriately begin with America's first
inhabitants, the Indians. Sioux Indians boiled sumac fruits to make a
styptic wash which reputedly stopped hemorrhaging in women after
parturition. Sioux brewed a tea from the roots which they drank "in case
of retention of urine and when urination was painful." For skin suffering
from poisoning, such as from some irritant vegetable oil, they applied
bruised and wetted leaves or fruits as a poultice. Nez Percé Indians similarly
moistened sumac leaves and placed them on skin rashes.

Flatheads made a tea from green or dry branches which they drank
for tuberculosis. They used the same branch for several batches of tea, the
first being green and later ones redder in color. The patient drank several
cups of this medicine each day and could not consume salt or sugar,
which caused coughing, they believed. Flatheads also used the fruits as a
purgative, although they gave no details regarding just how they prepared

the medicine. For sore throat, Kootenai Indians held a piece of cleaned sumac root in their mouths and swallowed its juice.

Non-Indians soon learned of sumac's healing powers, for its medicinal preparations eventually appeared in books of *materia medica*. Early American physicians claimed the bark of the root made a good antiseptic dressing for ulcers and open wounds. They used the infusion of bark as an astringent for sore mouths, diarrhea, dysentery, gonorrhea, and syphilis. They also used it as a wash in many skin complaints. A mucilage exudation was used in gleet and urinary difficulties. An infusion of the berries was used in diabetes, bowel complaints, febrile diseases, and as a wash for ringworm, tetters, and offensive ulcers.

C. F. Millspaugh, author of *American Medicinal Plants*, wrote, "I have known the juice of the root to remove warts," but humorously added, "I have also known these strange growths to disappear from the use of various innocuous 'charms,' such as a neighbor's potato surreptitiously obtained, rubbed upon the growths and cast over the left shoulder without noting its fall. . . ."

Wild food enthusiasts might want to prepare a beverage from the sumac fruits. But do not boil them, since this releases too much tannin. It is best to crush them in cold water, then strain the liquid through a cloth to remove hair and other debris. This beverage is pink or rose colored, and is best drunk cold, with sugar and ice cubes.

Other uses of smooth sumac include a Plains Indian tobacco mixture prepared from the leaves and a yellow-tan, gray, or black dye (depending upon the mordant used) made from the leaves, bark, and roots.

Description, Habitat, and Range

Smooth sumac is a one- to six-foot-tall shrub. The leaves are pinnately divided into leaflets, each segment being two to five inches in length. Its small flowers are whitish to greenish in color and are borne in dense, pyramid-like clusters. Its fruits are dry, about one-eighth inch in diameter, and densely covered with hairs.

Sumac inhabits foothills, lower mountain slopes, valleys, and streamsides. It is widespread in the United States and Canada, and even extends to Mexico; it is sometimes abundant in our area, often growing in dense patches.

Willow
Salix spp.

Willows constitute one of the largest genera of woody plants in terms of species and varieties and pose a confusing group for identification, even for the trained botanist. Several hundred grow from Africa and South America north to arctic-alpine climates. More than a hundred seventy-five species occur in North America alone; of these, only about thirty attain tree size. Of the twenty-nine species found in Montana, the following have achieved cultural importance to man: white willow (*Salix alba*), peachleaf willow (*Salix amygdaloides*), pussy willow (*Salix discolor*), coyote willow (*Salix exigua*), Mackenzie willow (*Salix mackenzieana*), and Scouler willow (*Salix scouleriana*). There are, of course, others of varying importance.

Man has long been familiar with willows. Their generic name, *Salix*, is a classical Celtic designation from *sal* (near) and *lis* (water), in reference to their usual growth near water. Seemingly everywhere man has employed willow for one thing or another, including medicine, crafts, construction, and ceremonies.

In the Old World, willows became important to man at an early date. The Greek physician Dioscordies (circa A.D. 60) was one of the first to describe their medicinal virtues. Later, in 1763, herbalists recommended the bark of the European white willow, *Salix alba*, for fever. It eventually came to enjoy widespread popularity in early America, and pharmacists employed it for its tonic, astringent, and antiperiodic qualities and found it useful for indigestion, worms, chronic diarrhea, and dysentery. Willow bark contains salicin, which some believe to decompose into salicylic acid in the human body. Salicylic acid is related to the drug aspirin, well known for its analgesic and febrifugal effects.

Although we do not know whether all willow barks contain salicin, let alone possess identical curative qualities, Montana Indians used willow bark in medicinal ways surprisingly similar to their European counterparts. Cheyenne Indians employed willow bark shavings (from *Salix amygdaloides*) to make a tea for diarrhea and other stomach complaints. Flatheads chewed the bark of an unknown willow with silvery leaves for stomach complaints such as diarrhea and summer flu. Flatheads and Cheyennes used willow as a remedy for cuts. Flatheads recommended that one chew the bark and place it on cuts and abrasions to allay pain and promote rapid healing; or, as Pete Beaverhead suggested, boil the bark and use the decoction as a wash, and place the crushed bark on the

cut with a clean cloth. Cheyennes fashioned a portion of peeled bark into a ring, which they placed on cuts to stop the flow of blood.

Indians attributed other healing qualities to willow. Flathead Indians made an eyewash from the leaves or young stem tips. Nez Percé and Crow Indians, historical allies, once used the willow as an emetic in conjunction with the sweatbath. Mickey Old Coyote, a Crow, said that they chewed willow stem tips to induce vomiting. Nez Percés used willow twigs "to clean out their insides." They tied three smooth sticks together and thrust them down the throat, the resulting vomiting producing a green bile. They believed that this bile caused a tired feeling and by forcing it out, a man would feel more energetic, light, and strong; he could easily face hardships and warfare. (Nez Percé women, incidentally, never practiced this remedy). Crow Indians also chewed willow bark to clean teeth, to prevent cavities, and to relieve headaches.

From the flexible willow wood the ingenious Montana Indians constructed a multitude of implements, craftware, furniture, and dwellings. Among these were: pins, pegs, backrests, and mattresses for the tipi, fishtraps, foxtraps, cradleboards, snowshoes, gambling wheels, walking sticks, stirrups for horsemen, scrapers for removing hair from hides, hoops for catching horses, baskets, drums, the framework for sweathouses and small hunting tipis, ropes, and meat racks.

Plains tribes such as the Cheyenne found peachleaf willow beneficent for their religious ceremonies. In the Sun Dance, for example, dancers wore wreaths of willow in the belief that because it grew near water, it would bring help to the thirsty dancers who went several days without food, water, or sleep.

Description, Habitat, and Range

Willows are deciduous trees or shrubs whose leaves are simple, generally long and narrow, and alternately attached to the slender stems. Willows have male and female flowers (catkins), which are borne on different plants, thus making identification all the more uncertain.

They generally inhabit stream banks and moist ground from low elevations to alpine environments.

Cascara Sagrada
Rhamnus purshiana DC.

Few people realize that one of the most important modern laxatives comes from a plant. Fewer still realize that this plant is native to northwestern America—a small tree named cascara sagrada (Spanish for "holy bark"). Indeed, it is sometimes referred to as the "all-American laxative."

Cascara bark is a drug of relatively recent origin, at least to the non-Indian world. Although Spanish and Mexican priests in California knew of the cathartic properties of a slightly different species, our species was not described until 1805 and was not introduced into medicine until 1877. Until that time the non-Indian world used the berries of the common European buckthorn as well as other vegetable sources: senna, rhubarb, and aloe. Today cascara sagrada provides the world one of the most widely used laxatives.

Cascara sagrada's cathartic properties did not escape northwest Indians, who undoubtedly learned of it long ago. In Montana, cascara occurs only in the northwestern region of the state. Undoubtedly, only the Kootenai and Flathead tribes who resided there became acquainted with its use. Constipated Indians purged themselves with a tea made from the bark. Flathead Indians believed that if the bark was procured by stripping it downward, then the drug would act as a purgative. On the other hand, if

stripping was upward, the drug would act as an emetic. "And if you don't believe it," commented one Flathead, "then try it yourself and you'll find out!"

Nowadays, pharmaceutical companies eagerly accept the bark for its medicinal purposes. It is recommended that it be collected from mid-April until the end of August, when it readily separates from the wood. After the trunk bark is removed, the tree is felled; then the branch bark is removed. This should be dried in shade and then stored in sacks, protected from rain and dampness to prevent mold or partial extraction of the chemical constituents. It is then ready for shipment. From one to three million pounds of the crude drug are used each year.

Cascara bark is principally collected from wild trees in British Columbia, Washington, Oregon, and California. Fortunately, shoots grow from the cut trunk, so new bark can again be collected from the same tree stump. Recently, small plantations have been started in the Pacific Northwest and in Kenya, Africa.

Constituents of cascara bark include anthraquinone derivatives, tannin, resins, starch, glucose, and other compounds. The freshly cut bark acts as a severe purgative, causing unpleasant griping. Proper curing—at least one year has been recommended—reduces this severity. Interestingly, Adeline Mathias and Alex Left-hand, two Kootenais from Hot Springs, Montana, recommended that the bark be kept as long as possible before usage. The drug is mainly taken as a liquid extract and elixir (which is less bitter tasting), or as tablets prepared from the dry extract. A mild tonic laxative, cascara is recommended for delicate or elderly persons.

Description, Habitat, and Range

Cascara is a tall shrub or small tree, standing ten to thirty-five feet in height and having a trunk four to twelve inches in diameter. The dark green, oblong leaves are two to six inches long and three-quarters to two and a half inches wide. The flowers are small and greenish white and are borne in axillary clusters. The black fruit is one-quarter to one-half inch in diameter.

It is a shrub of relatively moist, low-lying forested habitats and ranges from British Columbia to California and east to northwestern Montana.

Buffaloberry

Shepherdia argentea (Pursh) Nutt.

Eastern Montana Indians regarded the buffaloberry as a food *par excellence*. Found along streams and rivers lacing the grassy plains, this shrub often produced large quantities of brilliant red fruit. Indians preferred gathering them after an early fall freeze, which they believed sweetened them. They would gather them by hand picking, or preferably by beating the fruits off the bush onto a thin cover spread on the ground. After washing with water to remove leaves and twigs, they would eat them fresh or dry them for winter use. Occasionally Indians would pulverize them before drying. They often cooked the fruits into a sauce used to flavor buffalo meat. Some authors have claimed that this is the reason why the shrub is called buffaloberry; others believe it was named that because buffalo themselves were fond of it.

Nowadays people relish buffaloberries for making tasty jams and jellies.

Description, Habitat, and Range

Buffaloberry is a large, thorny shrub measuring up to twenty feet tall. It has silvery-scaly leaves three-quarters to two inches long. The flowers are small, inconspicuous, and unisexual. Some shrubs are therefore male, producing only pollen, while others are female, producing the brilliant berries, usually scarlet but sometimes yellow in color. The fruit is from one-eighth to one-quarter inch in diameter.

The shrub is found along streams, rivers, and low meadows in the prairie regions from Canada south to California, New Mexico, and Kansas.

Cattail

Typha latifolia L.

attail is perhaps the best known wild edible plant in the Northern Hemisphere. In just about every place that it occurs, people have utilized the rootstocks, fleshy stems, and flowers for food. But surprisingly, there are few references indicating that Montana Indians ate cattails, although they remember other uses. They made mats from cattail leaves, for example, which they used as floor material for the tipi, sweatbath, and Sun Dance lodge.

Some Plains Indians used the downy fruits to make a dressing for burns and scalds. They also used the down on infants to prevent chafing (as we use talcum powder), and as baby diaper wrappings. Sioux Indians treated smallpox by frying out coyote fat, which they mixed with the downy fruit of cattail and applied to the patient's pustules. Cheyenne and Crow Indians believed that if the down got into one's eyes, blindness or cataracts would result.

Wild food enthusiasts consider cattails an "outdoor pantry" because so many foods can be made from them. In the spring the young shoots can be pulled, the outer leaves peeled away, and the tender inner portion eaten raw or in salads; the shoots can also be cooked for about twenty-five minutes as a potherb. The cattail flower stalks, called spikes, are edible, too. Try boiling them for twenty minutes and then nibbling off the flowers from the stalk's core—like eating corn on the cob. Later, when the flower is more mature, collect the pollen. You can mix this with an equal amount of wheat flour to make muffins, cookies, biscuits, or pancakes.

Although the rootstocks can be collected at any time of the year, the fall seems to be the best time, since the starch content is probably higher then. The rootstocks should be peeled to expose the central white core. These can be eaten raw but are better boiled, baked, or pulverized to make a flour.

Description, Habitat, and Range

Cattails rise three and a half to eight feet from thick underground rootstocks. The long, linear leaves are a quarter to one inch wide. The minute brown flowers are clustered into a spike at the top of the spongy, unbranched stems.

This is a plant of wet places: swamps, marshes, shallow lakes, ditches, and stream borders. Cattail ranges widely in North America and Eurasia.

Horsetail

Equisetum hyemale L.

According to Kootenai Indians, the beautiful horsetail plant once looked quite ordinary. They say it was Coyote, the leading cultural hero of many western tribes, who gave the plant its characteristic stripes. Adeline Mathias, a Kootenai from Hot Springs, Montana, tells how it happened:

A long time ago this plant used to be green. There were no stripes. Coyote went along and somehow he pulled one of his stunts, his actions, and as a result, he fell in the river. There was no way he could get back on the dry land. He just kept swimming back and forth. Ah! (Adeline laughs). And the first thing that he saw right there next to the bank was this plant. Coyote just stood there and held on to it. He knew that he'd just pull once and the root would come out. Coyote said to the horsetail, "Please will you be strong and stay and pull me up. I'll use you to brace myself and get out of the water. When I do get out I'll give you a beautiful color. Besides,

now you're just nothing but green!" So the horsetail did. It held Coyote until he got on top of the bank. So Coyote kept his promise, and he took clay and he smashed it around the stem. He then took charcoal and he went over it . . . one stripe, two stripes, three stripes, all along. That's how come it has stripes. Otherwise it would be all green.

Horsetail is useful to man. Flathead and Crow Indians made a diuretic tea from the stems. The Crows prepared a hot poultice which they applied to the lower abdomen to relieve pain in the bladder and prostate areas. Blackfeet Indians boiled it and used the liquid as a drench for horse medicine. Cree women used horsetail to check menstrual irregularities. Non-Indians also knew of horsetail's diuretic properties. The plant was used in early American folk medicine, and it is listed as a diuretic in various *materia medicas*. The 1890 *Materia Medica* adds that horsetail once was thought useful for dropsy, hematuria, kidney diseases, and gonorrhea.

Many people discovered that the abrasive stems were useful as a kind of sandpaper substitute in craftwork, and some Indians still use them to polish pipes, bows, and arrows. Early American housewives gathered horsetail stems in bundles which they used to scrub and brighten tins, floors, and woodenware. Missouri River Indians also made mats from horsetails. You may want to make whistles from the stems, as Sioux children once did. But their elders warned them not to do so lest snakes should come.

Description, Habitat, and Range

The hollow and leafless green stems of this plant are two to three feet tall. They are jointed and ribbed and very tough to the touch. The horsetail bears no true flowers. It reproduces, rather, by spores located in cones at the tip of separate, whitish reproductive shoots.

Horsetail occurs in moist, low-lying habitats along streams and creek bottoms. A wide-ranging species, it is found in both the New and Old Worlds in the northern latitudes.

Other Common Names

Scouring rush.

Indian Breadroot

Psoralea esculenta Pursh

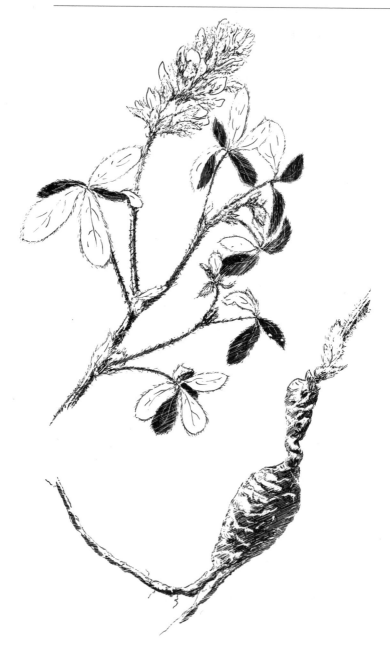

Sunlit prairies provided eastern Montana Indians with their most important root crop: the Indian breadroot or turnip. Normally gathering them in June when the soil was still moist and before the large roots became woody and the leafy tops dried and withered away, they peeled off the tough bark to expose the inner white core.

Occasionally they ate them raw, although some believed this caused indigestion and discomfort. Generally, they roasted them over a fire or in coals for a better meal. Sometimes they boiled them. For future use, they dried them in the sun. They cut the larger roots into shreds or into lengthwise sections to encourage more rapid drying, and stored them by hanging sections of the roots braided by the long, tapering ends. In winter, Indians mashed the dried roots and used them to thicken soups, to make mush or gruel, and to prepare cakes or breads which they baked over coals.

Early explorers and pioneers found breadroot an important wilderness food. The French called it *pomme blanche*, "white apple," or *pomme de prairie*, "apple of the prairie." One early French explorer, Lamare-Picquot, sent some of the roots back to France in 1800 in the belief that they might become an important crop plant. Although this never came about, breadroot continued to provide nourishment for American frontiersmen. As an example, John Colter, a member of the Lewis and Clark Expedition, later subsisted on these roots for about a week after he fled from hostile Indians.

Description, Habitat, and Range

Breadroots are perennial plants arising from deep-seated roots, these being up to four inches long. The stems are from four to twelve inches long. The leaves are pinnately divided into three to five leaflets, each three-quarters to two and a half inches long. The flowers are blue and mature into quarter-inch-long pods.

This is a plant of sunny prairies and rocky ground from Canada south to Missouri, Texas, and eastern Colorado.

Other Common Names

Indian Turnip.

Huckleberry
Vaccinium globulare Rydb.

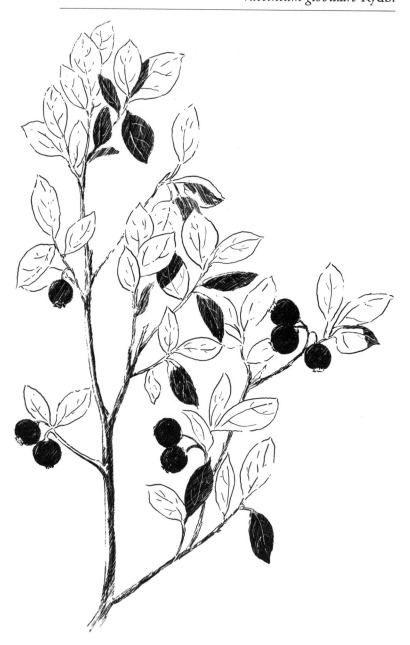

Although other Indian berries have declined in importance in recent years, not so the huckleberry. Each summer western Montana Indians travel to their accustomed berry-picking haunts, where women still fill buckets of these deliciously sweet berries. Long ago, Indians preserved the fruit for winter use by spreading the berries thinly on a flat rock in the open and letting the sun dry them for a few days. During the winter they prepared these sun-dried berries by boiling, either by themselves or with various roots. Indians apparently seldom mixed huckleberries with pemmican, a food made by mashing berries and meat and adding grease.

Today, huckleberry-picking is popular with almost everyone. What people do not immediately eat, they use in pancake and muffin recipes, or they make jams and jellies.

Flathead Indians used the huckleberry plant as a medicine. For heart trouble, arthritis, and rheumatism, they drank a tea made from the roots and stems.

Description, Habitat, and Range

Huckleberry plants are small- to medium-sized shrubs. The stems are reddish and are grooved. The shiny leaves are small, one to two inches long and about half of that in width. The vase-shaped, rose-colored flowers mature into bluish berries which are one-half to three-quarters of an inch in diameter.

This huckleberry is found in the moister forests of the Rocky Mountains. It becomes especially abundant in some areas after forest fires or logging. There are many species of huckleberry; they occur in the northern latitudes of North America, especially in acid soils. This species is the most conspicuous in our region and produces the most easily harvested berries.

Yampah

Perideridia gairdneri
(H. & A.) Mathias

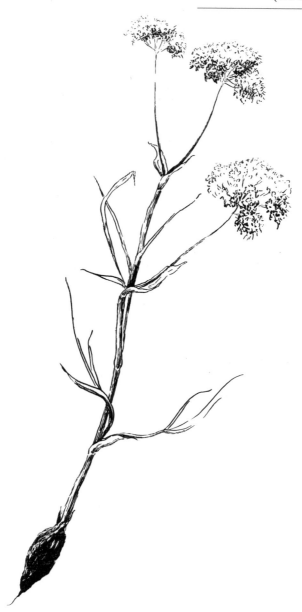

Yampah, or "Indian carrot" roots, probably taste better than any other wild roots found in Montana. They have a delicious, sweet, and nutty flavor without any bitterness. Indians and pioneers regularly dug for this savory treat, and even today some Montanans find it pleasant eating.

Indians normally dug yampah roots in spring or early summer. The best time to dig them, claimed several Flathead Indians, was when the plant was in flower. Raw yampah roots have a delicious flavor, very similar to domestic carrots. Indians sometimes boiled them for a meal, and what they did not immediately consume they dried and saved for winter use. Flathead Indians, for example, first boiled and then smashed the roots to form them into small, round cakes which they sun dried. Cheyenne Indians similarly preserved them for winter use by scraping and then drying; or they cooked, dried, and then pulverized the roots, which they made into mush by pouring soup over them.

Description, Habitat, and Range

Yampah is a tall herb, growing to a height of from one to three and a half feet. Its roots are tuberlike and occur alone or in clusters. The leaves are pinnately divided into narrow and grasslike leaflets which measure from one to six inches long; these wither by the time the small white flowers blossom.

Yampah is a plant of moist, grassy meadows and ranges from Alberta and British Columbia south to New Mexico and California.

Other Common Names

Indian Carrot.

Cottonwood

Populus deltoides Bartr. ex Marsh.
Populus balsamifera L.

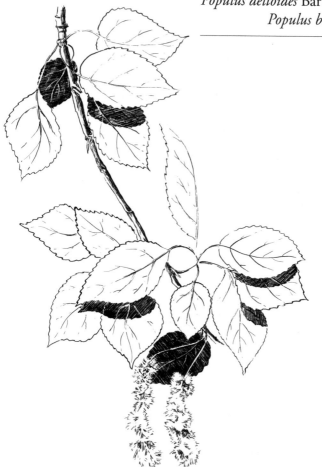

Plains Indians still practice their ancient midsummer religious ceremony, the Sun Dance. To construct a lodge for this sacred rite, Indians used a cottonwood trunk for the center pole. Cheyennes deployed a special scout to ceremonially locate the cottonwood and return to camp to announce his find; this scout was chosen on the basis that he had once discovered an enemy and returned to camp to share the news. The man chosen to ceremonially cut down the tree must have struck an enemy with a hatchet. In preparing to cut down the tree, he made four motions with his hatchet, meanwhile reciting his coup achievement.

For food, Indians such as Flathead, Kootenai, and Blackfeet relished the sweet inner bark and sap of the cottonwood. Flatheads liked this sap more than that of any other tree species, and Kootenai thought it sweeter than ponderosa pine bark. Indians peeled the bark in spring, normally in May, when the sap was running. They first sampled a small portion of bark to test its sweetness, and, if suitable, they began removing large pieces with the rib of a buffalo or elk. Next they scraped off the thin, transparent sheets of cambium which still clung to the tree. Kootenai Indians hollowed a portion of the trunk to collect the sap for eating.

Horses liked to eat cottonwood, too. Cheyenne and numerous other Indians fed young twigs and bark to their beasts of burden when other forage was not available. Some even took bark with them on war parties to feed the stock. And to conceal their human scent when stealing enemy horses, Blackfeet warriors rubbed themselves with cottonwood sap.

If the trees died from girdling, perhaps the Indians did not mind, for cottonwood makes excellent firewood. They generally liked the upper branches, however, and got these by tying a hooked pole to the ends of branches and pulling them down. Cottonwood does not crackle, and it makes a clean smoke, excellent qualifications for tipi fires.

Indians extracted dyes and paints from certain plants. Cottonwood was one which gave color to brighten their belongings. George Bird Grinnell, renowned historian of the Cheyenne and other tribes, stated that Cheyennes used the buds in springtime to paint records of deeds on robes; he said they mixed these with blood to produce a black color which did not wear off. Indians of the Missouri River region got a yellow dye from cottonwood buds. But Mary Fisher, a Cheyenne woman, said that the fruits produced various colors—red, green, yellow, purple, and white. She tested the colors by marking them on sandstone, claiming that different fruits gave different colors, and with them painted tipis and suitcases.

Occasionally Indians sought to cure themselves with cottonwood. Flatheads and Kootenais applied the leaves as a poultice for bruises, sores, and boils, believing that it drew the pus out of the infections. Nez Percés plastered the leaves around a sore arm to relieve aching muscles or used them as a poultice for horses' sores infected with maggots. Kootenais drank tea made from the bark for tuberculosis and whooping cough, after which they drank warm water, since they believed the medicine to

be somewhat poisonous. They recommended taking this medicine for several weeks to be really effective. For syphilis, Flathead Indians drank a tea made from the very young branches and buds of cottonwood, the roots of cinquefoil (*Potentilla glandulosa*), and wild rose (*Rosa* spp.). They also believed eating cottonwood bark to be good for colds.

Description, Habitat, and Range

Black cottonwood and plains cottonwood are common in Montana; the former is more widespread in the west while the latter is frequently found in eastern sections of the state.

Black cottonwood is the largest of cottonwoods, reaching heights of one hundred and twenty feet. Its leaves are oval, lanceolate, or heart shaped; they are finely toothed on the margins, dark green above and pale beneath, thick and leathery, three to seven inches long and three to four inches wide. The trunk is gray or nearly black when wet; it becomes deeply furrowed with age.

Plains cottonwood is similar in many ways but is smaller, reaching heights of sixty to ninety feet. The leaves are broadly triangular, three to six inches long and almost as broad, and with roughly toothed margins.

Mint

Mentha arvensis L.

Man's use of mint dates to early history. The ancients used it to scent their bath water; Athenians perfumed their bodies with its fragrance, and at feasts Greeks and Romans crowned themselves with its foliage. Mint was offered as payment to the Pharisees in Biblical times, along with anise and cumin. Baucis and Philemon of Greek mythology scoured their festive board with mint before laying food on it for divine guests. The Roman scholar Pliny wrote that "the smell of mint does stir up the mind and the taste to a greedy desire of meat." Even its generic name, *Mentha*, attests to this plant's ancient place in history. The name is derived from the mythological Menthe, a nymph loved by Pluto.

The jealous Proserpine changed the nymph into the mint plant, thus preventing Pluto from possessing her.

Many Montana Indians are still knowledgeable of ways in which their peoples once used mint. Generally, they brewed it into a tea which they believed was effective medicine for many illnesses.

Flathead, Kootenai, and other tribes variously drank mint tea for colds, coughs, fevers, and similar complaints. Its therapeutic value in this regard seems sound, especially if we can compare it to the European peppermint, *Mentha piperita*. Herbalists have described peppermint as diaphoretic (causing one to sweat), antispasmodic (preventing or allaying spasms or cramps), and helpful in eliminating mucous from the bronchial areas. These are all properties indicated in treating respiratory illnesses.

Kootenai Indians treated rheumatism and arthritis with mint leaves. Adeline Mathias of Hot Springs said that the "cooked works were placed on the ache." A bandage then secured the poultice in place. Similarly, early doctors employed the essential oil of mint, menthol, as a rubefacient to bring relief to rheumatic and neurologic pain.

Both Euramerican and Indian cultures drank mint tea as a remedy for vomiting. Cheyenne Indians ground the leaves and stems finely and drank the resulting potion for relief. Early pharmacists pointed out that menthol was useful for its anti-emetic properties, the action of which prevents "retching and vomiting."

Indian people found mint useful in yet other ways. Flatheads and Kootenais sometimes drank the tea as a tonic. Flatheads packed the leaves around a carious tooth to bring relief. Kootenais drank the tea for kidney problems, while the Gros Ventres believed the brew to be remedial for headache.

Mint was widely used for its fragrant and germicidal properties. Many tribes once hung mint in their dwellings for its pleasing aroma. Cheyennes used it for "Indian perfume" and chewed the leaves and put them on their bodies. This was believed to improve their love life! Sioux Indians placed their traps in a mint solution to conceal human scent, while Flatheads and Kootenais sprinkled the powdered leaves on meat and berries to repel bugs.

Of the thirty species of this plant found around the world, three occur in the Rocky Mountain region. The indigenous field mint (*Mentha arvensis*) achieved greater importance among the New World Indians,

while the introduced spearmint (*Mentha spicata*) and peppermint (*Mentha piperita*) were more important among Old World herbalists and in modern medicine. These two European species were cultivated at an early date and possibly came to the New World with the Pilgrims. They are useful for diarrhea, stomach and bowel troubles, colic, flatulency, cough, toothache, headache, and hysteria. Both are favorites as flavoring agents in gums, soaps, candies, and pharmaceutical preparations.

Mints can be used in a variety of ways as tea, condiment, and food, with only a lack of imagination limiting its uses for flavoring meats, vegetables, and soups.

Description, Habitat, and Range

Mint is a strong-odored perennial herb rising from one to three feet from creeping rootstocks. The small flowers, colored light blue to faint pink, are clustered in the leaf axils. The leaves are finely toothed, somewhat hairy, and oppositely attached on the square stem. The plant blooms in July and August.

It inhabits damp soil, especially streambanks, springs, and bogs. It is found in the northern hemisphere of the Old and New Worlds, where it is associated with the boreal forest.

Horsemint

Monarda fistulosa L., and related species

The American explorer, pioneer, or wilderness traveler, often far from the help of doctors, frequently had little choice but to administer Indian remedies for relief from sickness and pain. Some died agonizing deaths in spite of Indian-learned medicines, yet others were cured. Horsemint was one such remedy which brought relief. William Bratton, a member of the Lewis and Clark Expedition, suffered for some time from a great weakness in the loins and could not walk or sit upright. After members of the corps exhausted their medicinal resources, the hunter Shields suggested using an Indian cure, a sweatbath and a medicinal tea made from horsemint. After sweating in the bath, immersing in cold water, and then drinking the tea, Bratton walked again the next day. No doubt others learned of the medicinal value of horsemint, for it soon became an important remedy in early American folk medicine.

Pharmacists attribute diaphoretic properties to horsemint; that is, it causes profuse sweating. In view of this, the Flathead Indian use of its tea for colds, flu, fever, pneumonia, and chills seems well chosen, since sweating helps to cure these kinds of sicknesses. Pete Beaverhead, a Flathead from Ronan, Montana, described horsemint as one of the finest medicines known for fevers, pneumonia, and other respiratory ailments. He said that the patient should drink about a quart of it, then cover himself with blankets. He will begin to sweat profusely. Although the treatment will reduce the fever, Pete continued, the patient should stay in bed. Crow Indians also found horsemint tea helpful in treating respiratory ailments.

Indian women drank horsemint tea for female complaints. Pregnant Flathead women drank it, while others took it to help expel afterbirth. Sioux women used it after confinement. Similarly, modern pharmacists describe horsemint as an emmenagogue; that is, it encourages menstrual flow.

Indians and non-Indians shared other common remedies in horsemint. While Sioux Indians drank horsemint tea for abdominal pains, later pharmacists would describe it as a carminative, causing gas to be expelled from the stomach, intestine, and bowels, thus finding it useful for sick stomach and flatulent colic. And Kootenai Indians and the medical profession would come to agree that horsemint tea was efficacious in treating certain kidney complaints.

Native Americans ascribed still other cures to horsemint: Christine Woodcock and Annie Pierre, two Flatheads, recommended it as cough

medicine. Other Flatheads found it effective for toothache; they simply packed it around the aching area for relief. Blackfeet and Flathead Indians made a solution for eye medicine. Pete Beaverhead, a Flathead, said to place a cloth soaked in this solution over the eyes to alleviate soreness.

In other ways, Indians used horsemint for its aromatic properties. Kootenais placed the leaves on hot rocks in sweathouses to give off a pleasant aroma. Cheyennes perfumed their favorite horses, especially the manes and tails, with the chewed leaves. Flatheads used this same aroma as a meat preservative; they pulverized the leaves and sprinkled the powder on meat to keep bugs away. They also hung bundles of these plants on walls to give relief from colds. Crow Indians mixed horsemint with other sweet-smelling plants and sometimes a drop of beaver castor oil; they moistened this mixture and applied it to their hair, body, or clothing as a perfume.

As a medicinal plant, horsemint has served both the Native American and European American. First learned about by America's original inhabitants, horsemint achieved a place in history as a pioneer remedy and eventually became an officially recognized drug in the *United States Dispensatory* from 1882 to 1950 and in the *National Formulary* since 1950.

Description, Habitat, and Range

A member of the mint family, horsemint is a perennial herb and has rose- to purple-colored flowers arranged in heads measuring from one to three inches across. These are located at the ends of the unbranched stems, which grow to a height of from one to three feet. The brightly colored green leaves are ovate to lance shaped, measure from two to four inches long, and are toothed on the margins.

Horsemint frequents relatively dry to moist soil in valleys, prairies, and mountains. It ranges widely in the Rocky Mountain region from Alberta to Arizona and east to Manitoba and Texas.

Other Common Names

Beebalm. Lemon mint. Wild bergamot.

Water Hemlock

Cicuta douglasii (DC.) Coult. & Rose

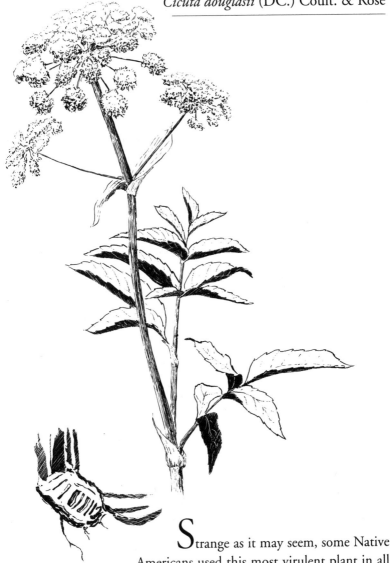

Strange as it may seem, some Native Americans used this most virulent plant in all North America as a medicine. Actually, a great number of herbs used in healing are poisonous in certain concentrations and dosages, yet with proper administration, they are effective medicinally. Indeed, Flathead and Kootenai Indians recognized the plant as violently poisonous. So

too, did other, if not all, tribes where it occurs. Some Kootenai cautiously used it to induce vomiting.

Adeline Mathias and Alex Left-hand of Hot Springs, Montana, explained its use:

> It is used as medicine if you use it right. If you don't it'll kill you. They say you take a little bit of the root and make a tea. When you take a half cup of it you also take about a quart or a half gallon of warm water and down the whole works and then heave it all up. You can't keep just the tea in you. You got to drink something that will make you throw up right now. It has something to do with your insides.
>
> For headache you put some of the roots in a rag and start smelling it. Just the smell gets in there and goes all over.
>
> It can't be handled by any people that don't know what it is. It's good for heartburn too, but I wouldn't chance it.
>
> I know of an old lady that gave me some of that root. It was powdered up like salt. Somehow it got into the food or something, and I almost died on New Year's Day. I was out. Later they knew what caused it. It was this root.
>
> In the past she took her daughter's life with it. It was the only daughter she had. It was Lame Joe's wife. She had this daughter who was ill. She thought she knew her daughter better. She fixed this root into a tea and gave it to her. She didn't last twenty minutes.

Indians recognized other medicinal uses of water hemlock. Kootenais pounded the root to make a medicine for sores. Some Indians suffering from rattlesnake bites were given a portion of the split root to use as a poultice to draw the poison out.

Regardless of the medicinal preparation of water hemlock, its poisonous properties were dealt with very cautiously, since human cases of poisoning did occur. Indeed, some Indians intentionally committed suicide by ingesting it. The symptoms are dreadful. The poisonous principal, cicutoxin, acts directly on the central nervous system, and effects may occur within fifteen minutes of ingestion. First noted is excessive salivation, followed by tremors and violent convulsions. The victim occasionally chews his tongue to shreds. The pupils of the eyes become dilated, and the body temperature rises by several degrees. Vomiting may occur, and if so, the chances of survival become somewhat better. Know this plant well. Some have mistaken its roots for wild parsnips, with fatal results.

Description, Habitat, and Range

Water hemlock is a perennial herb which rises two to four feet from thickened rootstocks. The leaves are pinnately compound, each leaf being one to four inches long and toothed on the margins. The white flowers are arranged in a compound, terminal, flat-topped cluster. Water hemlock is a member of the parsley family and is easily confused with other closely related species. This poisonous plant can be distinguished by two characteristics: One is the rootstock. A longitudinal slice reveals horizontal cross-sections separating hollow cavities. The other is leaf venation. The lateral veins terminate between the teeth of the leaflets.

Water hemlock inhabits swamps, ditches, streambanks, and wet meadows from the Rocky Mountains west to the coast. Other species can be found in other sections of the United States and Canada.

False Hellebore

Veratrum viride Ait.

Some plants are both medicinal and poisonous, depending upon the amount ingested. Hellebore is one such plant whose poisonous properties have been used medicinally. Long known to American Indians, it eventually passed to colonial folk medicine and thence to modern medical practice.

Flathead, Kootenai, and other tribes of our region knew of this robust herb as "sneeze-root" after the manner in which they used it as a decongestant. They dried and powdered the rootstock to sniff up their noses. The resultant sneezing, sometimes violent, cleared the nasal passages. Because of its powerful action, they generally did not allow its use on children.

Indians of eastern Montana found hellebore an important medicine, even though it is rarely found there. To obtain this valuable root, Indians would travel great distances to trade with western Montana tribes. It no doubt brought a handsome price.

The newly arrived Europeans quickly incorporated hellebore into their *materia medica*. As early as 1750, Swedish naturalist Peter Kalm reported:

> Some people boil the root for medical purposes, washing scorbutic parts with the water or decoction. This is said to cause some pain, and even a plentiful discharge of urine, but the patient is said to be cured thereby. When the children here are plagued with vermin, they boil this root, and put the comb into the decoction, and comb the head with it, and this kills the lice most effectually.

Americans during the Revolutionary War could not obtain the closely related European form of hellebore, *Veratrum album*, which up to that time was the principal medicinal form. Americans then began to use our New World species in its place. The early physician Dr. Bigelow mentioned the successful use of the plant for gout, and in time, hellebore became well known. The action of the root has been described as emetic, alterative, epispastic, deobstruent, errhine, narcotic, diaphoretic, sedative, and insecticidal. It was additionally found useful in the treatment of rheumatism, lung diseases, asthma, dyspepsia, and bowel complaints. Hellebore was officially recognized in the *United States Dispensatory* from 1820 to 1942 and in the *National Formulary* from 1942 to 1960.

The principal medical use of hellebore in recent times has been as a heart depressant and spinal paralyzant. Scientists have found its medicinal action to be due to veratrum, an alkaloid chemical. Because of its variable potency and unpredictable toxicity, preparations for medicine gradually fell into disuse.

The alkaloid principle of this plant is concentrated in the young shoots and in the roots. Grazing animals have been poisoned from eating the shoots. Idaho sheep which have ingested them have given birth to malformed, monkey-faced lambs, some with only a single, median eye. Even honey bees frequenting the flowers have succumbed to its poison.

On the other hand, the toxic principle of the alkaloid was found useful in agriculture. Before planting corn, early farmers soaked the kernels in a decoction of the root. Crop-damaging birds which unknowingly ate these contaminated grains became so giddy as to frighten away the remainder of the molesting flock.

No one should attempt self-medication with this potent root, since it can be poisonous to humans if taken in sufficient concentrations. Those who have ingested it have experienced salivation, a depressed heart action, a burning sensation in the mouth and throat, hallucination, and at the very least, a mild headache.

Description, Habitat, and Range

Hellebore is a coarse perennial herb which stands from three to six feet tall. The unbranched, erect stems rise from thickened rootstocks. The alternate, elliptical to lance-shaped leaves are six to twelve inches long and three to six inches broad. The yellowish-green flowers are grouped in long terminal clusters, from six inches to two feet long.

It is found in moist areas, from low wooded habitats to higher mountain meadows. It ranges throughout much of the United States.

Bibliography

Benson, E. M., J. M. Peters, M. A. Edwards, and L. A. Hogan, "Nutritive Values of Wild Edible Plants of the Pacific Northwest," *Journal of American Dietetic Association*, 62: 43, 1973.

Blankinship, J. W. "Native Economic Plants of Montana," *Montana Agricultural Experiment Station Bulletin*, No. 56. Bozeman: Montana Agricultural Station, 1905.

Booth, W. E. and J. C. Wright. *Flora of Montana*. Bozeman: Montana State University Press, 1959.

Chickering, J. W. "Catalogue of Phanerograms and Vasculare Cryptogamous Plants Collected by Dr. Elliot Coues, U.S.A., in Dakota and Montana," U.S. Geological and Geographical Survey. 4: 801-30. Washington, 1878.

Clark, Ella. *Indian Legends From the Northern Rockies*. Norman: University of Oklahoma Press, 1966.

Collingwood, G. H. and W. D. Brush. *Knowing Your Trees*. Washington, D.C.: The American Forestry Association, 1957.

Coues, E. *The History of the Lewis and Clark Expedition*. 4 Vols., New York, 1893.

Craighead, J. F. C. and R. J. David. *A Field Guide to Rocky Mountain Wildflowers*. Boston: Houghton Mifflin Company, 1963.

Dieteret, R. Unpublished manuscript. Missoula: University of Montana, 1955.

Dock, L. L. *Materia Medica for Nurses*. New York and London: G. P. Putnams Sons, 1890.

Dorn, R. D. *Vascular Plants of Montana*. Cheyenne, Wyoming: Mountain West Publishing, 1984.

Geyer, C. A. "Notes on the Vegetation and General Characteristics of the Missouri and Oregon Territories, During the Years 1843 and 1844." *London Journal of Botany*. 4: 479-92, 653-62 (1845): 5: 22-41, 208, 285-310, 509-24 (1846).

Gibbons, E. *Stalking the Wild Asparagus*. New York: David McKay Company, Inc., 1962.

Gibbons, E. *Stalking the Healthful Herbs*. New York: David McKay Company, Inc., 1966.

Gilmore, M. R. "Uses of Plants by the Indians of the Upper Missouri River Region," *33rd Annual Report*, Bureau of American Ethnology, Smithsonian Institution, Washington, D.C., 1919.

Grieve, M. *A Modern Herbal*. New York: Dover Publications, Inc., 1931.

Grinnell, G. B. *The Cheyenne Indians: Their History and Ways of Life*. Vol. II. New Haven, 1923.

Hare. *The National Standard Dispensatory*. Lea Bros., 1905.

Harbinger, L. J. "The Importance of Food Plants in the Maintenance of Nez Percé Cultural Identity," M.A. thesis. Pullman: Washington State, 1964.

Harrington, H. D. *Edible Native Plants of the Rocky Mountains*. Albuquerque: University of New Mexico Press, 1967.

Hart, J. "Plant Taxonomy of the Salish and Kootenai Indians of Western Montana," M.A. thesis. University of Montana, Missoula, 1974.

Hart, J. Unpublished ethnobotany field notes.

Havard, V. "Plants of Western Dakota and Eastern Montana Collected During 1877 and 1879," Annual Report, Chief of Engineers, App. SS, 1880: 1-20. Washington.

Heiser, C. B. Jr. "The Sunflower Among the North American Indians," *American Philosophical Society*, Vol. 95, No. 4, August, 1951.

Henkel, A. "Wild Medicinal Plants of the U.S." U.S.D.A. *Bureau of Plant Industries, Bulletin* 89, 1906.

Hitchcock, C. L. and A. Cronquist. *Flora of the Pacific Northwest*. Seattle: University of Washington Press, 1973.

Hooper, H. M. "Traditional Foods of the Northern Cheyenne Indians," M.A. thesis. University of Delaware, 1975.

Johnston, A. "Blackfeet Indian Utilization of the Flora of the Northwestern Great Plains," *Economic Botany*. 24: 301-24, 1970.

Kingsbury, J. M. *Poisonous Plants of the United States and Canada*. Englewood Cliffs, New Jersey: Prentice-Hall, Inc., 1964.

Malouf, R. T. "Camas and the Flathead Indians of Montana," Research Paper, University of Michigan, 1971.

McMinn, H. E. and E. Maino. *Pacific Coast Trees*. Berkeley and Los Angeles: University of California Press, 1963.

Millspaugh, C. F. *American Medicinal Plants, An Illustrated and Descriptive Guide to Plants Indigenous to and Naturalized in the United States Which are Used in Medicine*. New York: Dover Publications, 1974.

Moss, E. H. *Flora of Alberta*. University of Toronto Press, 1959.

Murray, G. F. "The Bitterroot in Science and History," M.A. thesis. University of Montana, Missoula, 1929.

National Formulary. American Pharmaceutical Association, Baltimore, 1888-1975.

Nuttall, T. "A Catalogue of a Collection of Plants Made Chiefly in the Valleys of the Rocky Mountains of the Columbia River by Mr. Nathaniel B. Wyeth," *Journal Academy Philadelphia*. 7: 5-60, 1834.

Organic Materia Medica. Parke, Davis & Co., 1890.

Phillips, P. C. *Medicine in the Making of Montana*. Missoula: Montana State University Press, 1962.

Plants of South Dakota Grasslands. Bulletin 566, Agricultural Experiment Station, South Dakota State University, Brookings, South Dakota, 1970.

Powell, P. J. *Sweet Medicine*. Norman: University of Oklahoma Press, 1969.

Sayre, L. E. *A Manual of Organic Materia Medica and Pharmacognosy*. Fourth Edition. Philadelphia: P. Blakiston's Son & Co., 1917.

Schaeffer, C. E. "The Subsistence Quest of the Kootenai: A Study of Interaction of Culture and Environment," Unpublished Ph.D. dissertation. University of Pennsylvania, Philadelphia, 1940.

Stubbs, R. D. "An Investigation of the Edible and Medicinal Plants Used by the Flathead Indians," M. A. thesis. University of Montana, Missoula, 1966.

Stuhr, E. T. "Oregon Drug Plants—A Survey of the Official Plants of Oregon," *Monograph from the Press of the American Pharmaceutical Association*, 1931.

Toineeta, Joy (Yellowtail). "Absarog-Issawau" (from the land of the Crow Indians), M.A. thesis. Montana State University, Bozeman, 1970.

Trease, G. E. *Pharmacognosy*. London: Bailliere Tindall, 1972.

Turner, N. T. "Ethnobotany of the Upper Kootenai Indians of Cranbrook and Tobacco Plains, B.C." Unpublished field notes, 1974.

Turney-High, H. H. "The Flathead Indians of Montana," *Memoirs of the American Anthropological Association*, No. 48. Menasha, Wisconsin: American Anthropological Association, 1937.

Turney-High, H. H. "Ethnography of the Kutenai," *Memoirs of the American Anthropological Association*, No. 56, Menasha, Wisconsin: American Anthropological Association, 1941.

U.S. Dispensatory. Philadelphia: J. P. Lippincott Company, 1833-1960.

Vogel, V. T. *American Indian Medicine.* Norman: University of Oklahoma Press, 1970.

White, T. "Scarred Trees in Western Montana," *Montana State University Anthropological and Sociological Papers*, No. 17, Missoula: Montana State University Press, 1954.

Williams, L. O. "Drug and Condiment Plants," *Agricultural Handbook* No. 172, Agricultural Research Service, U. S. Department of Agriculture, Washington, D.C., 1960.

Yanovsky, E. "Food Plants of the North American Indians," Misc. Pub. No. 237, U.S. Dept. Agr., Washington, D.C., 1936.

Youngken, H. W. "Drugs of the North American Indians," *American Journal of Pharmacy*, Vol. 94, (July, 1924), 485-502; Vol. 97, (March, 1925), 158-85; (April, 1925), 257-71.

Youngken, H. W. *Textbook of Pharmacognosy*, 6th edition. Philadelphia: The Blakiston Co., 1948.

Index of native plants

Where more than one reference is noted, the main entry has been placed in bold-face.

A

Abies lasiocarpa, 1
Acer glabrum, 13
Acer negundo, 4
Achillea millefolium, 7
Actaea rubra, xiv, **10**, 51
Alder, **6**, 28
Allium cernuum, 14
Allium douglasii, 28
Alnus incana, 6
Alumroot, 64-65
Amelanchier alnifolia, 12
Apocynum androsaemifolium, 19
Apocynum cannabinum, 18-19
Arctostaphylos uva-ursi, 38, **82**
Artemisia dracunculus, 92-93
Artemisia frigida, 92-93
Artemisia ludoviciana, **90**, 93
Artemisia tridentata, 93
Asclepias speciosa, 68

B

Balsamorhiza sagittata, 37
Balsam, 3. *See also* fir.
Balsamroot, 28, **37**, 96
Baneberry, **10-11**, 51
Barberry, 33. *See also* Oregon grape.
Bearberry, 38, **83**, 85
Bear root, 50
Beebalm, 138. *See also* horsemint.
Biscuitroot, 48-50
Bitterroot, 25, 47, **94-100**, 102
Black tree lichen, **16-17**, 28

Boxelder, 4-5
Breadroot, 49-50
Bryoria fremontii, **16**, 28
Buckbrush, 2, 45
Buffaloberry, 12, 87, **119**

C

Camas, 17, **22-30**, 37, 49, 89, 97
Camassia quamash, 22
Cascara sagrada, 117-18
Canada buffaloberry, 107-8
Cattail, 120-21
Ceanothus velutinus, 2, 45-46
Cedar, 78. *See also* Rocky Mountain juniper and western red cedar.
Chimaphila umbellata, 72
Chokecherry, xiv, 12, **86-89**, 95
Cicuta douglasii, 139
Cinquefoil, 132
Cirsium scariosum, 20
Claytonia lanceolata, 57
Cornus stolonifera, **38**, 83
Cottonwood, 41, **130-32**
Cousroot, 49-50

D, E, F

Dogbane, 19. *See also* Indian hemp.
Douglas onion, 17, 28
Echinacea angustifolia, 52
Equisetum hyemale, 122
Erythronium grandiflorum, 44
False hellebore, 83, **142-44**

Index

The Author

Jeff Hart spent several summers in the 1970s in ethnobotanical research among Montana's Indian tribes, especially the few living "Old Ones," whose knowledge of the medicinal qualities of native plants assisted in the preparation of the text published here. The lore gathered from them was augmented by Hart's own professional training, which included a B.A. in Environmental Biology and an M.A. in Botany. Since finishing this book, Hart has conducted botanical field work in South America and earned a Ph.D. in evolutionary biology from Harvard University. He now lives in Sacramento, California, where he works as an environmental consultant. The time he spent with the elders in preparing this manuscript still fuels his appreciation of Native American values and wisdom.

The Artist

Jacqueline Moore, a native of Washington State, resided in Montana for twenty-two years, where she lived while creating the illustrations for this book. Her home and studio is presently located on the Middle Fork of the Clearwater River in central Idaho near the confluence of the wild and scenic Lochsa and Selway Rivers. Moore's considerable artistic talent has been entirely self-developed. Employed as a commercial artist for twenty years specializing in scientific illustration, she now devotes her artistic endeavors to fine art. Adept in many media, her works include oil and acrylic paintings, water colors, pen and ink, and serigraphs and are in private collections across the U.S., Canada, the U.K. and in numerous publications. She uses nature as her inspiration especially favoring landscape and floral subjects.